THE
Archive Photographs
SERIES

CARSHALTON
WALLINGTON AND BEDDINGTON

THE
Archive Photographs
SERIES

CARSHALTON
WALLINGTON AND BEDDINGTON

Compiled by
John Phillips, Kathleen Shawcross and Nick Harris

TEMPUS

First published 1995, reprinted 2003

Tempus Publishing Limited
The Mill, Brimscombe Port,
Stroud, Gloucestershire, GL5 2QG

British Library Cataloguing in Publication Data.
A catalogue record for this book is available from the British Library.

ISBN 0 7524 0341 9

Typesetting and origination by Tempus Publishing Limited.
Printed in Great Britain by Midway Colour Print, Wiltshire.

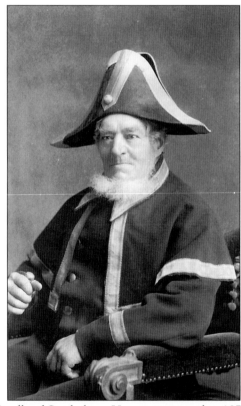

Charles Bone, the last Beadle of Carshalton. He was appointed in 1879 and died in 1904.

Contents

Introduction

Covering the history of the former parishes of Carshalton and Beddington, which included the village of Wallington until its separation in 1867, this book fills a gap in the Borough of Sutton's local history. Frank Burgess has produced a splendid series of photographic histories of Sutton and Cheam but, up to now, the eastern side of the borough has lacked a comparable volume.

The earliest surviving photos of the area were taken around 1860 so this pictorial history covers the last 150 years - a period of immense change both nationally and in the local area. In 1860 Carshalton, Beddington and Wallington were villages standing in the countryside to the south of London. They expanded steadily in the second half of the nineteenth century and were overwhelmed by suburban development in the 1920s and 1930s. By 1939 most of the area was built up, with the exception of the Croydon sewage farm in the northern part of Beddington and an open area around the small holdings at the south end of Wallington and Carshalton.

Within this overall pattern of development the three villages had significantly different histories. For four hundred years Beddington was dominated by the Carew family who lived in the manor house next to St Mary's church (now Carew Manor School). There were several other large houses in Beddington and most of the land in the parish was in the hands of a few wealthy people. They appear to have run Beddington as a 'closed' village in which they restricted the number of tenants to keep down the cost of poor relief which was borne by the parish rate. Several new large houses were built after the Carew estates were sold in 1859 but the landowners were fairly successful at keeping the property developers at bay until the end of the century. They must have been helped in this by the lack of a good railway station to serve the village. The area developed very rapidly between the wars when a substantial part of the south end of the parish became Croydon airport — London's first international terminal.

Carshalton had a long history of fragmented land ownership so there was much less control of its development. Its pleasant springs and streams and the hunting and racing on the Downs made it a popular country retreat for wealthy Londoners from at least the seventeenth century. In 1868 there were around fourteen large houses in the parish and the village also had an exceptionally large number of water mills along the Wandle. By the end of the 1860s some areas — like Mill Lane — had developed an industrial character and an industrial area had also grown around Goat Green at the north end of Carshalton and Wallington. Here there were leather works by the Wandle and also a corn mill and a mill for grinding drugs and dyes.

Carshalton's first railway station was what is now Wallington station, as the owner of the Carshalton Park Estate, which occupied most of the land to the south of the village, would not allow it to be built closer. It was opened in 1847. The present Carshalton station was opened when the Sutton to Mitcham Junction line was built in 1868. The Beeches station was opened in 1907 to serve the houses that were beginning to spread southwards along Beeches Avenue.

Carshalton expanded rapidly between the wars. The largest development was the St Helier Estate, built by the former London County Council. Construction was carried out between 1929 and 1936 and was on such a large scale that a branch railway line was laid to bring material on to the site.

In the mid-nineteenth century Wallington was a small village which centred on the Green and included several large houses and their grounds. It must once have been the most important of the three settlements as it gave its name to Wallington Hundred, the Saxon administrative unit for this part of Surrey. A separate settlement developed around Carshalton station, to the south of Wallington, which gradually expanded and merged with the older village.

From 1860, when the transition from the rural to urban was still in its infancy stages, numerous photos have survived to document the course of change and to allow us glimpses into a world that has gone for ever. What follows is a selection from the extensive collection housed in Sutton's Archive and Local Studies Searchroom in the Central Library.

John Phillips, October 1995

One
Carshalton

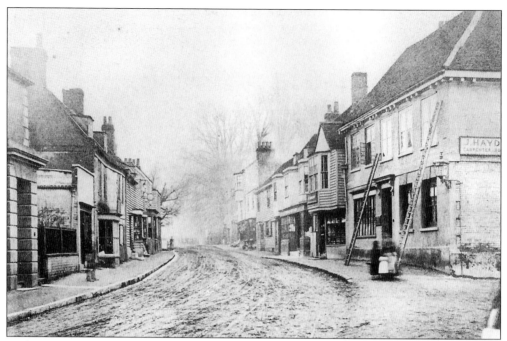

Looking east along Carshalton High Street, *c.* 1870. The trees in the centre are in the grounds of Carshalton Park House.

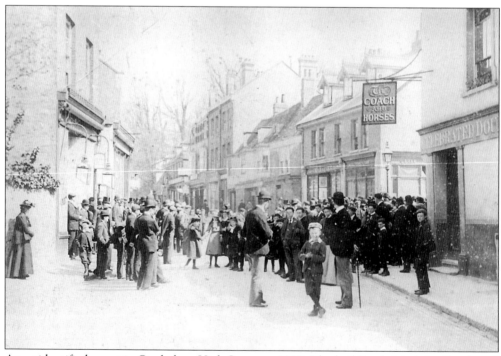

An unidentified event in Carshalton High Street, *c.* 1900. The building behind the Coach and Horses sign, which was partly occupied by the London and Provincial Bank, has been faced in stone and is now Barclay's Bank.

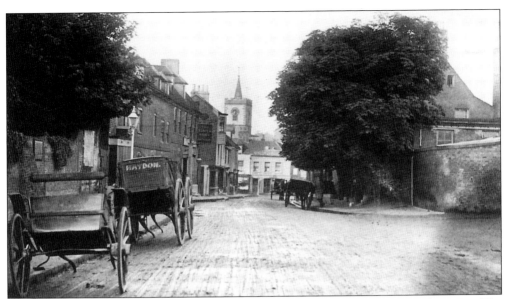

Looking west along Carshalton High Street before the Church was enlarged in the 1890s. The King's Arms on the left was bombed during the Second World War. Haydon's operated a butchers shop on the right side of the High Street from the mid-eighteenth century.

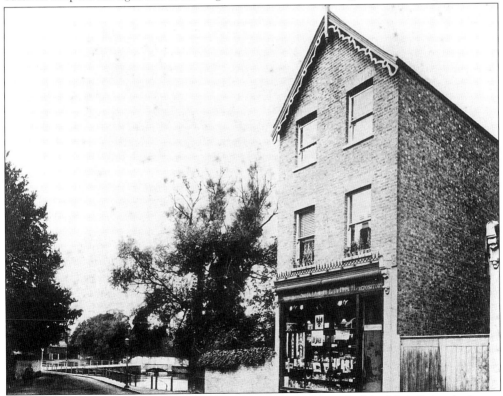

Susannah Rotherham's stationery and book shop at the west end of the High Street by Lower Pond. In the 1880s she operated a sub-post office from this building which now houses Lloyd's Bank.

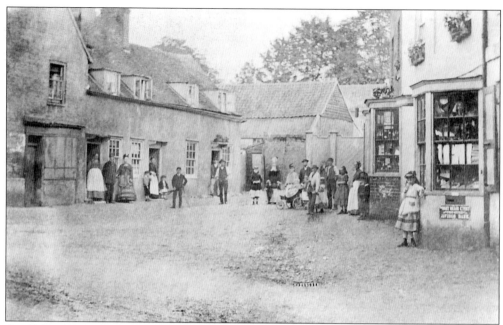

Carshalton post office in The Square, 1875. It was a money order office as well as a post office and savings bank. The large gates in the background gave access to Carshalton Park House.

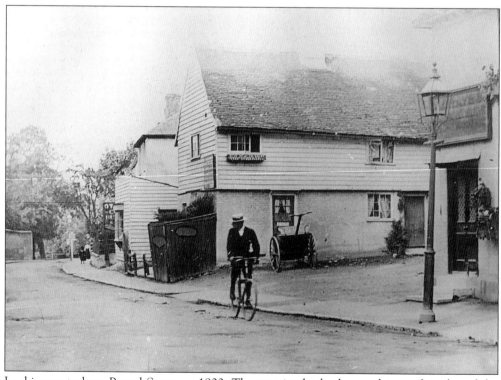

Looking east along Pound Street, c. 1900. The tree in the background is on the edge of the Upper Pond.

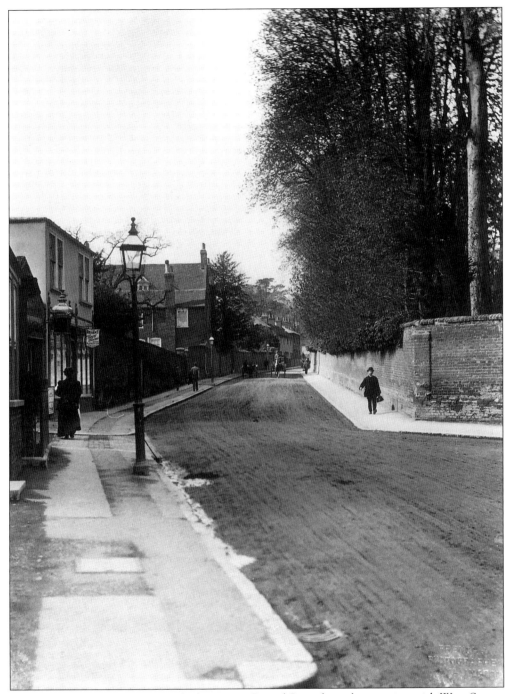

Pound Street, *c.* 1906. The view looks west up Pound Steet from the junction with West Street. Gas lighting has been installed but the road still has a gravel surface. The back of a large house, owned by the Wallace family, can be seen behind the lamp. On the right is the boundary wall of Carshalton House (now St. Philomena's).

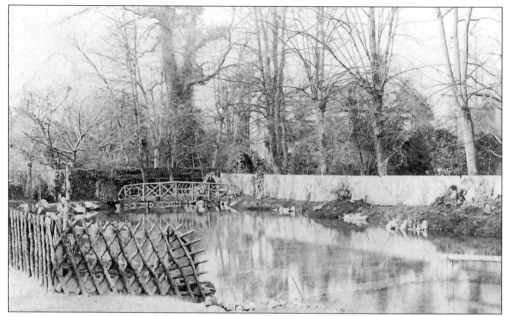

Margaret's Pool, *c.* 1900. When John Ruskin wrote *The Crown of Wild Olive* in 1872 he complained about the inhabitants of Carshalton casting 'their street and house foulness' into the Carshalton springs. He later paid for this spring to be beautified and asked it to be called Margaret's Pool in memory of his mother.

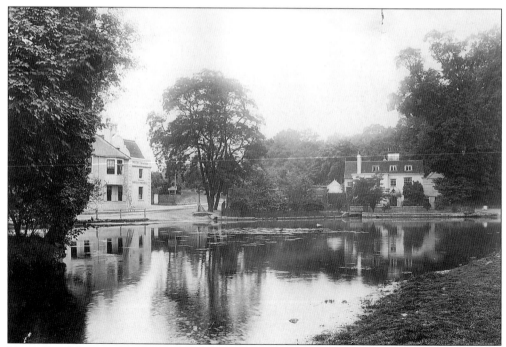

Upper Pond showing Honeywood and the Greyhound in 1896. The photo was taken before the Edwardian extension was added to Honeywood around 1903 by the merchant, John Pattinson Kirk.

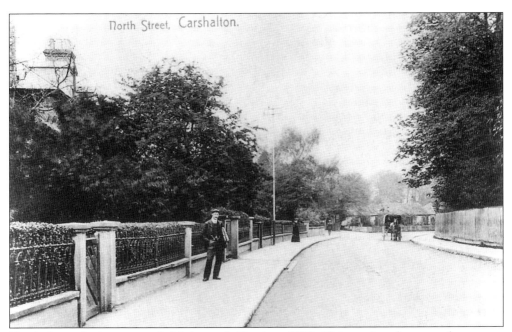

North Street looking towards Nightingale Road, *c.* 1900. This section, between the present railway station and the Wrythe was realigned before 1840 and was for a time known as New Road. The northern end of the road towards the Wrythe was not developed until the second half of the nineteenth century.

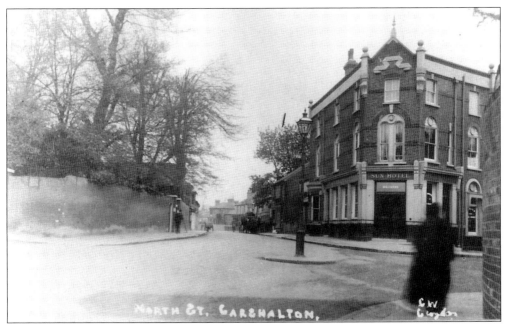

North Street looking north from the junction with Mill Lane (right) and West Street Lane (left). The Sun public house was erected as a hotel by the Croydon brewers, Nalder and Collyer, between 1866 and 1868.

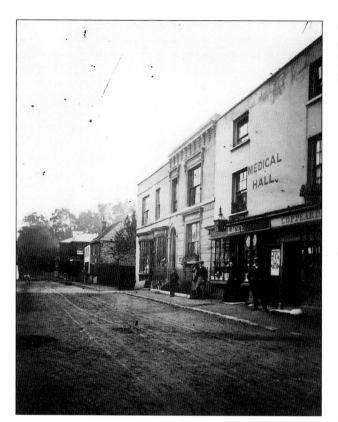

West Street looking south from the junction with West Street Lane, *c*. 1870. The Swan Inn can be seen in the distance.

West Street looking north towards the railway bridge, *c*. 1870. The railway bridge must have been recently completed as the line was under construction when the first large scale Ordnance Survey map was drawn up in 1868.

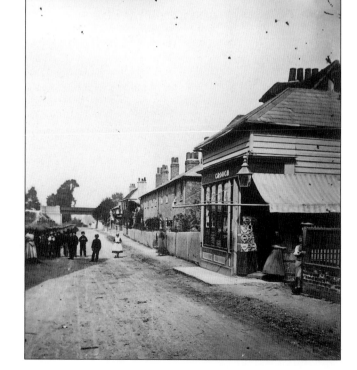

West Street Lane seen from West Street, c. 1870.

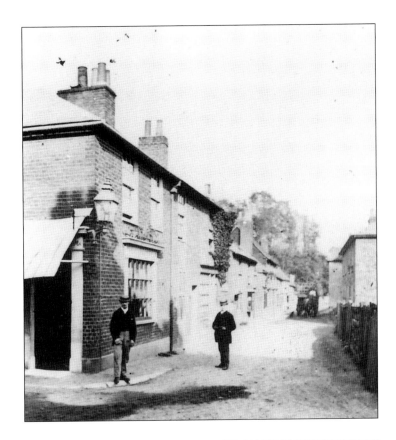

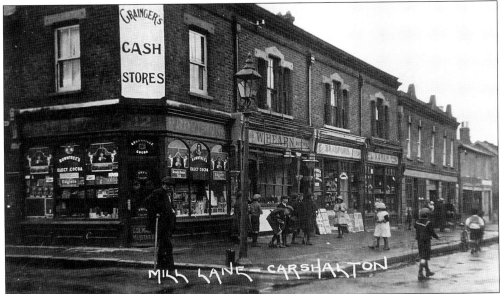

Mill Lane with Rochester Road on the left. Grainger's cash stores had a very brief existance as they only appear in the street directory for 1922-3. The directory for 1921 lists R. Bean running a grocery store on this corner and by 1923-4 the shop was operated by F.C. Curd who was also a grocer.

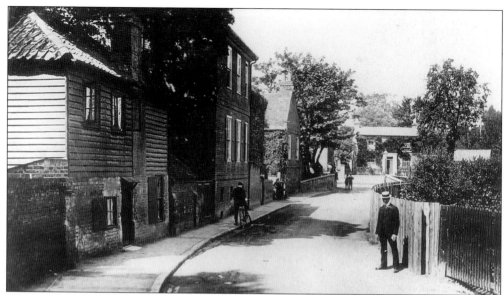

Butter Hill looking towards Butter Hill Bridge. The origin of the name 'Butter Hill' is unknown. The two boys in the background are standing on Butter Hill Bridge. The building to the left of them was the house attached to Lower Mill. At this time it was owned by Denyer's and operated as a flour mill. Ansell's snuff mills also stood above the bridge.

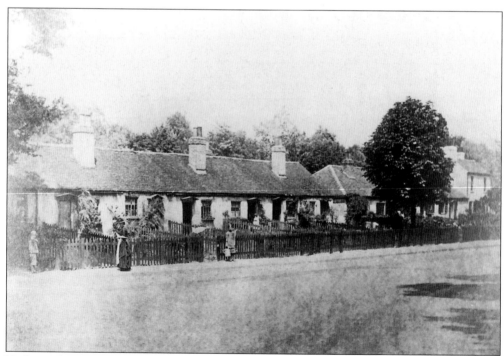

Nightingale Row on the north side of Nightingale Road next to Wrythe Green, c. 1850. These cottages were part of the Culvers Estate. When they were sold, in 1866, they were described as 'A compact cottage property of eleven houses and gardens' producing a rental of £78 per year. Cooper Crescent now occupies the site.

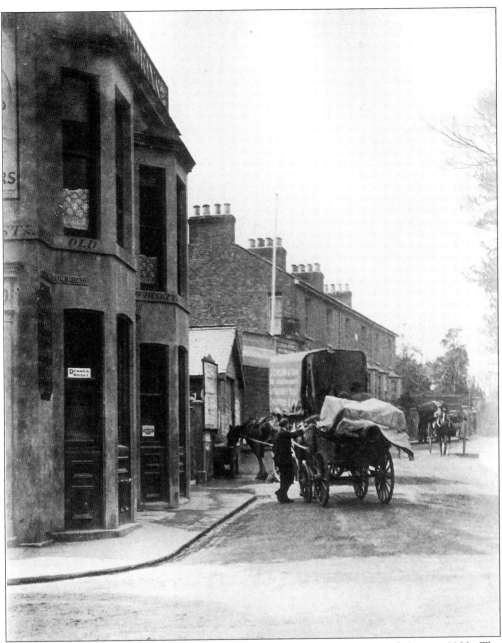

Carshalton Road looking towards Sutton from the junction with Pound Street, 1903. The building on the right is the Windsor Castle public house. There may have been a small beer shop on this site before the present pub was erected in about 1858. It has been extensively altered since the photo was taken. The windows and doors were modified and the lower part of the building covered in glazed tiles.

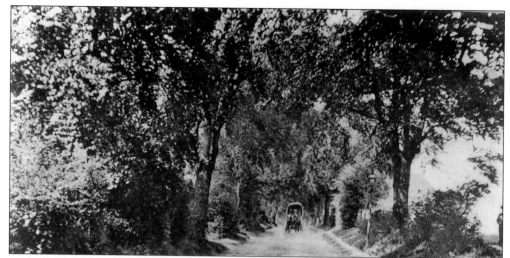

Beeches Avenue in the late-nineteenth century. This road across the Downs appears to have been lined with trees by the late eighteenth century but it is not known who planted them or when. It was called Beech Avenue in the late nineteenth century, then Beechnut Tree Walk, and The Beeches before the name settled to its modern form. The road retained its rural character until the very end of the nineteenth century when new housing began to spread south from the station.

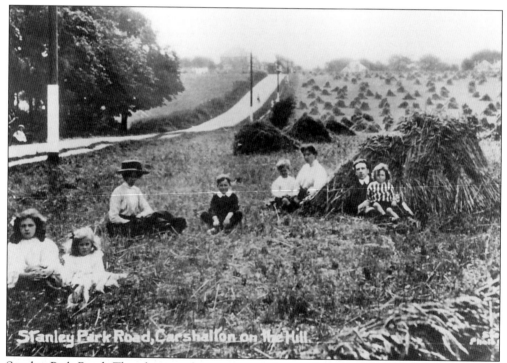

Stanley Park Road. The photographer appears to be standing on the north side of the road looking west. Warnham Court Road has since been built in the shallow valley in the middle distance and the tops of the houses along Beeches Avenue can be seen in the background. The photo was probably taken in the decade before the First World War.

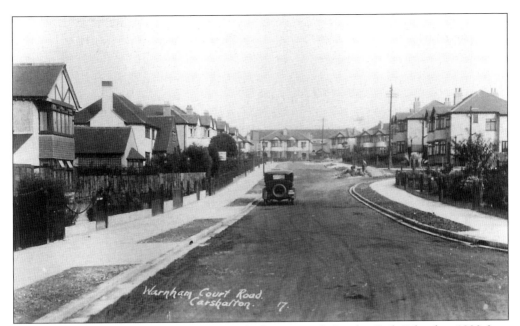

Warnham Court Road, Carshalton Beeches looking towards Stanley Park School, c. 1932-3. This estate, which was developed in the second half of the 1920s, appears to have been in the final stages of completion when this photo was taken.

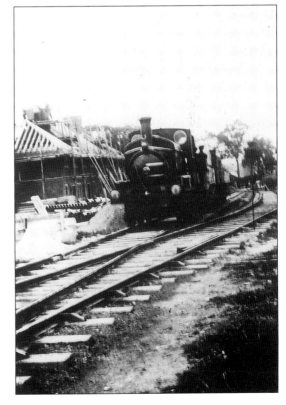

The construction of the St Helier Estate by the London County Council, 1929-36. The bulk of the building material was delivered to sidings in Mitcham whence a specially built light-railway system took the wagons direct to the building sites. The railway had no signals so the crossings of public roads were protected by gates and warning boards.

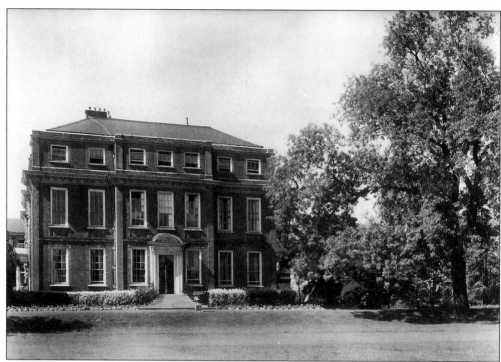

The east front of Carshalton House in 1949. Carshalton House was built for Edward Carlton, a London tobacco merchant about 1700. It is now used as St. Philomena's School.

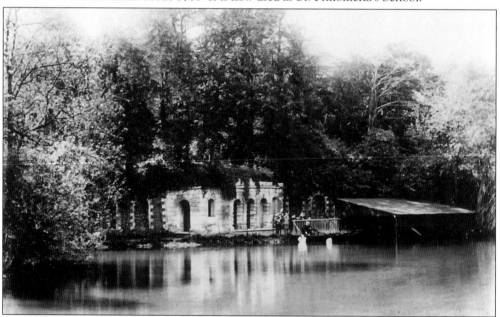

The Hermitage and lake, Carshalton House, *c.* 1900 The Hermitage is an ornamental garden building which dates from the early eighteenth century and may have been part of the garden that was created for the financier Sir John Fellowes who owned the house from 1716 to about 1721. The lake was created in its present form when the grounds were re-landscaped in the second half of the eighteenth century.

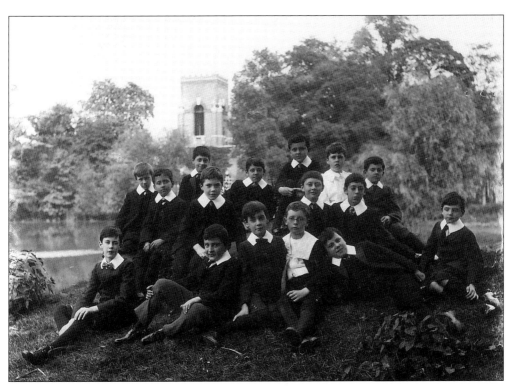

New pupils at the boys' prep school, St Philomena's Convent, *c.* 1912 with the water tower in the background. The boys boarded in St Aloysius House before the scheme was abandoned, not long after this photograph was taken.

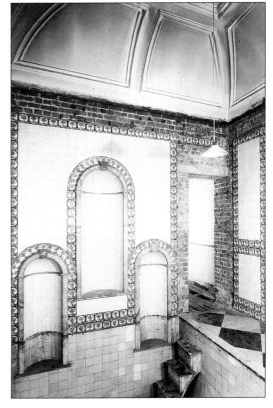

The cold bath in the water tower, Carshalton House. The water tower was built for Sir John Fellowes and contained a water wheel which drove a pump that filled a cistern in the top of the tower. Cold bathing was fashionable in the late seventeenth and early eigtheenth centuries and this is a rare survival of a private bath of the period. The room is decorated with tin glazed tiles and the floor round the bath is covered with marble.

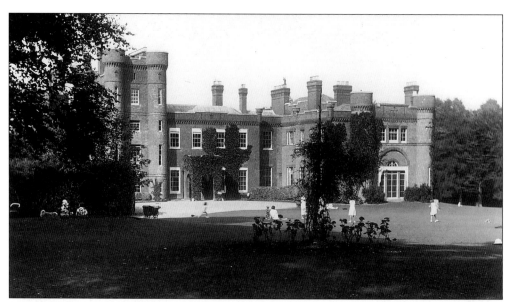

The Oaks between the wars. The 12th Earl of Derby acquired a lease of the Oaks in 1771 and subsequently employed Robert Adam to rebuild it. However, the work was abandoned when his wife left him to live with the Duke of Dorset. The Earl was keenly interested in horse racing and both the Oaks and the Derby were devised and named in this house. The central section of the house was gutted by fire in the middle of the nineteenth century, and was then rebuilt in the Adam manner. It was demolished between 1956 and 1960

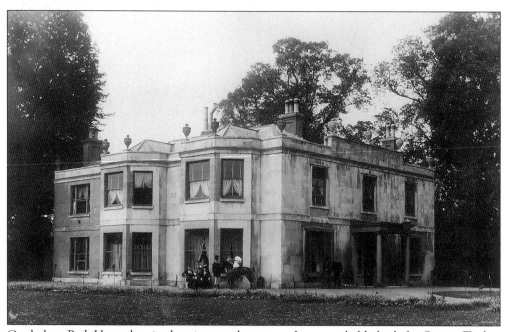

Carshalton Park House late in the nineteenth century. It was probably built for George Taylor, a West Indian sugar planter who bought the estate from the Scawens in the early 1780s, it was demolished in 1927. The site lies between Ruskin Road and the High Street near the east end of Brookside.

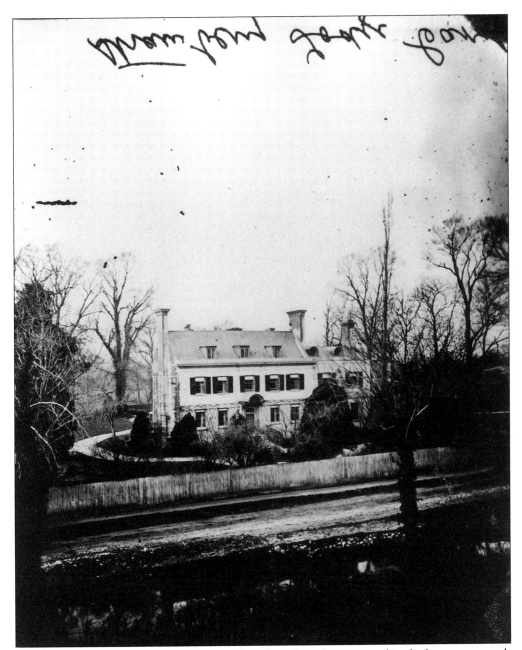

Strawberry Lodge, Mill Lane, c. 1870. It is thought to have been erected in the late seventeenth century by Josias Dewye who owned gunpowder mills at the junction of the Beddington and Carshalton branches of the Wandle. It still stands and is presently undergoing refurbishment by Carshalton Baptist church.

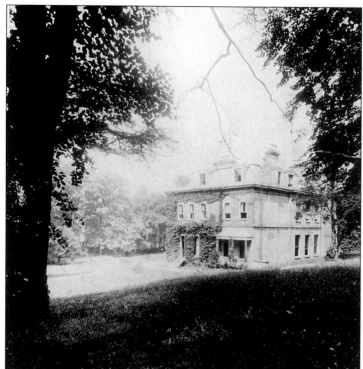

Barrow Hedges which stood on the west side of Beeches Avenue about 650 yards south of Carshalton Beeches railway station. The house can be traced back to the late seventeenth century. In the eighteenth century it was, for a time, an inn which was frequented by the horse-racing fraternity.

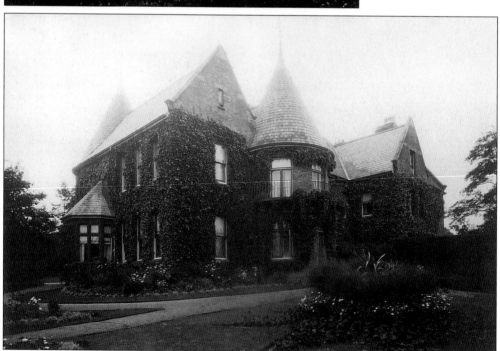

Anglesey, early this century. Like many large suburban middle class houses it was erected in the late nineteenth century, at the present corner of Anglesey Gardens and Stanley Park Road. It was a particularly fine example, with a roof slated in the manner of a French Chateau. The house was demolished before 1933.

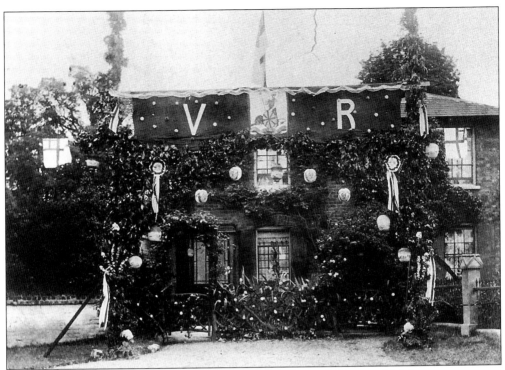

Madeley Cottage, Church Hill, decorated for Queen Victoria's Diamond Jubilee.

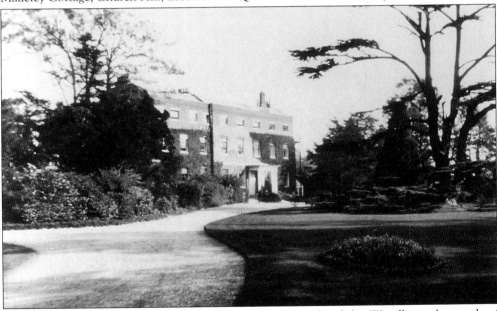

Shepley House, *c.* 1900. This house stood on the west side of the Wandle to the north of Strawberry Lane. There appears to have been a large house on the site since the seventeenth century. The building shown in the photo was erected in 1773/74 by John Dewye Parker for George Shepley who operated oil and leather mills on the Wandle. It was demolished in 1932 or 1933 after being used as a convalescent home by the National Union of Printing and Paper Workers.

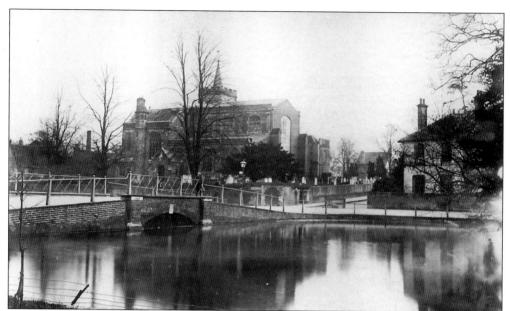

All Saint's church is Carshalton's ancient parish church, parts of which date back to the middle ages. This photo was taken after a new nave, north aisle and chancel had been added in the 1890s but before the rebuilding of the west front was completed in 1913. The door at the corner of the church yard leads to the old fire engine shed used from 1836-1867. The circular railings to the right of it enclose Anne Boleyn's Well.

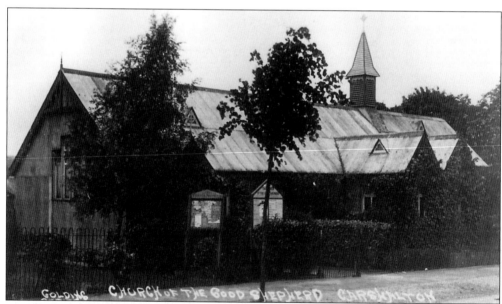

The Church of the Good Shepherd, c. 1926. Development along Stanley Park Road appears to have started in the 1860s and to have progressed slowly. In 1890 a small corrugated iron church was erected to serve the area. In 1900 this was replaced by the iron church shown here, which stood in Stanley Park Road nearly opposite the end of Stanley Road. It was superseded by the brick church in Queen Mary's Avenue in 1930.

Ruskin Road Methodist church. The first Methodist church in Carshalton was erected in North Street in 1861. This was replaced by a new church in Ruskin Road, 1911-12, but during the 1920s the congregation grew so rapidly that a new building was erected next to the earlier church, which was retained as a hall.

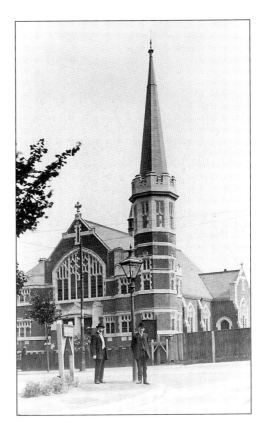

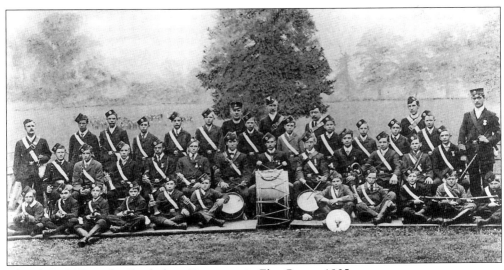

Church Lads' Brigade, Carshalton Company, in Elm Grove, 1905.

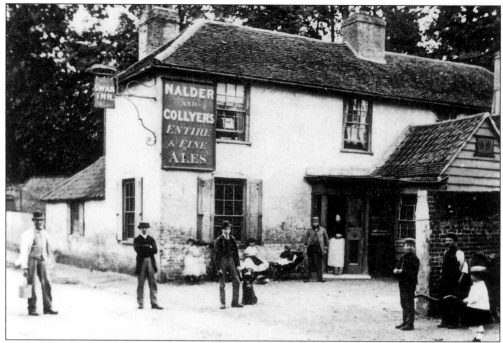

Swan Inn, West Street, *c.* 1870. This stood on the west side of West Street close to the Carshalton House boundary wall. Its history can be traced back to the beginning of the eighteenth century when it was known as the Old Swan Ale House. In the mid-nineteenth century it was the starting point for a coach to London, but it went into decline thereafter and ceased trading as a pub about 1909.

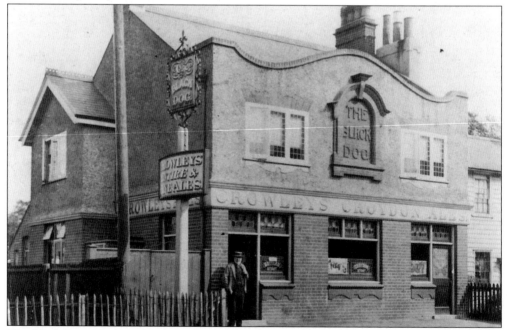

The Black Dog stood on the east side of North Street at the corner with Rochester Road. The first known reference to it is in 1828 and it last appeared in the trade directories in 1907.

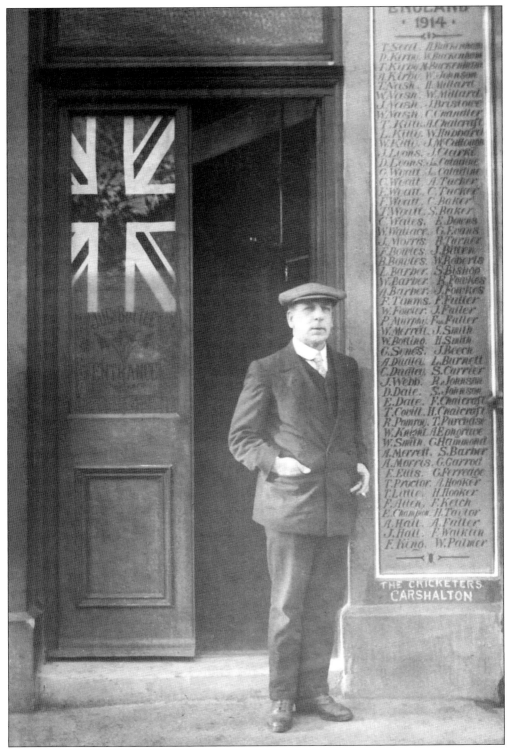

'Heroes of the Wrythe — Gone to Fight for England 1914'. The Cricketers public house, Wrythe Lane.

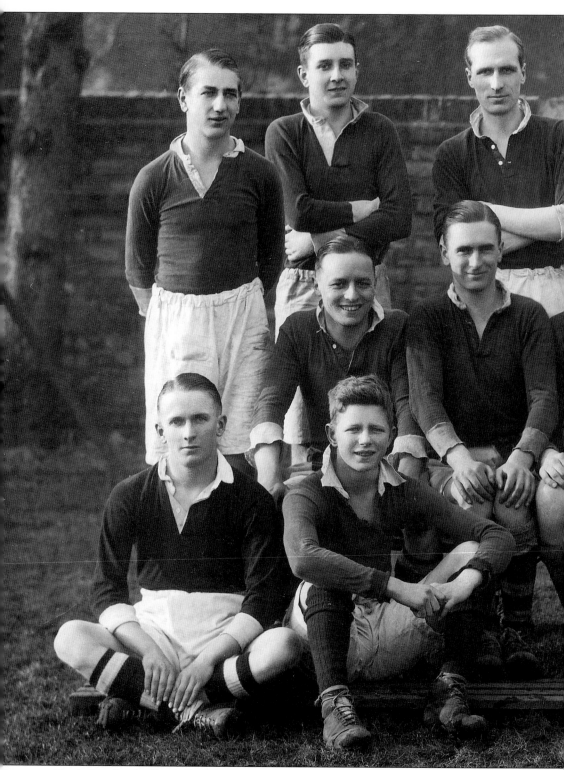

Carshalton Rugby Football Club.

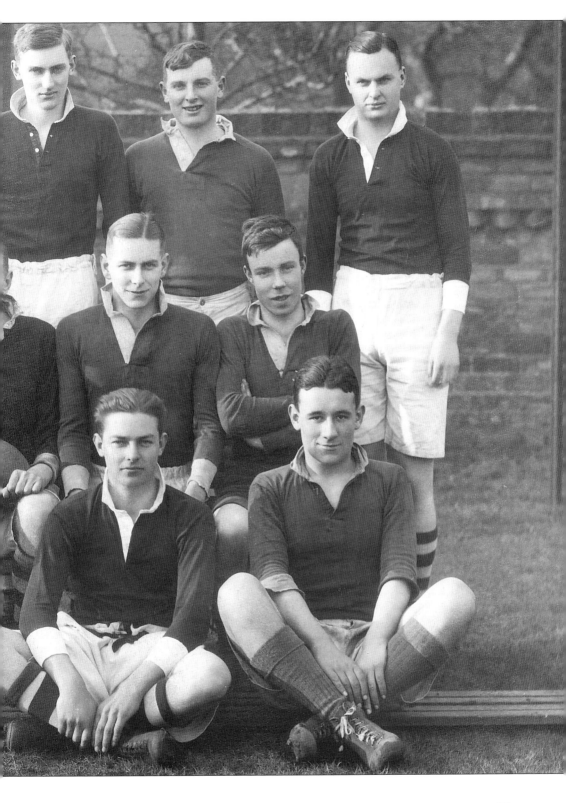

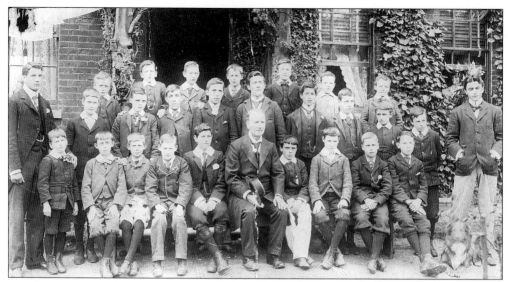

Boarding students in front of Leicester House School, late nineteenth century. Built as a workhouse in 1792, the building became a convalescent asylum in 1833; the Royal Hospital for Incurables in 1854 and a British School around 1857. In the 1860s Josias Baines took over and ran it as a boarding school for young gentlemen. It was sold in 1895, became Carshalton College in 1909 and was finally demolished in the late 1920s.

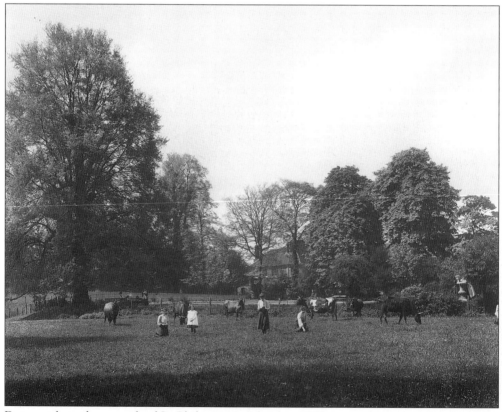

Dairy cattle in the grounds of St. Philomena's School, c. 1908.

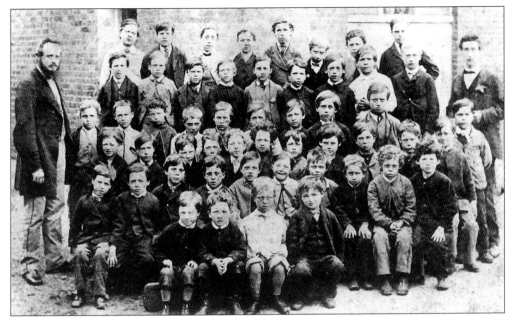

Pupils of the National School, West Street. Before elementary schooling became a state concern in 1870, the Church of England had a network of charitably-funded national schools to provide a rudimentary education to poor children. Carshalton's school was built around 1820. An upper floor was added in 1854 and was used for the boys while the girls used the ground floor. The master on the left may be James Mellon Bickford who also ran a stationers shop and was secretary of the local gas company.

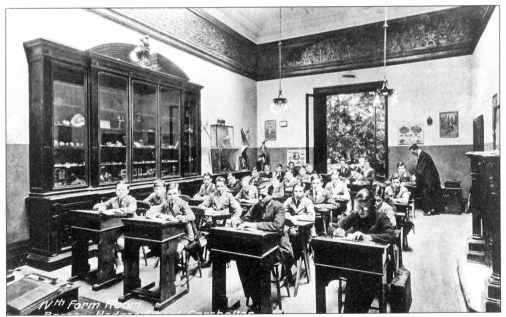

Barrow Hedges School, fourth form room. The boarding school was established in the early 1920s by Mr H R Budgell, 'for sons of professional men and boys of a like class'. The school was closed and house demolished in the late 1930s.

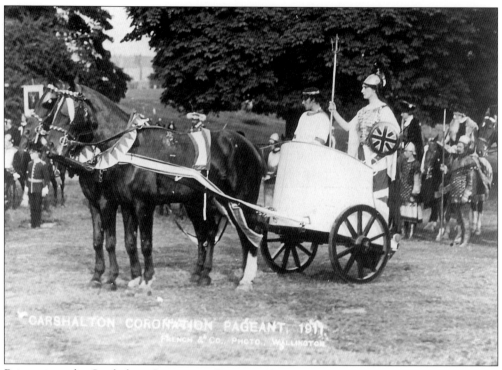

Britannia at the Carshalton Coronation Pageant, 1911.

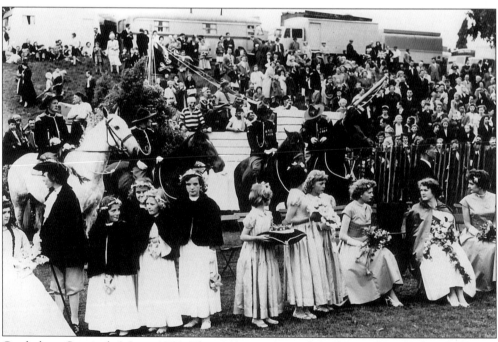

Carshalton Carnival, 2 June 1956. The picture seems to have been taken in the Hog Pit in Carshalton Park. In the foreground, second from the right, is the Carnival Queen, Gillian Mace, and her attendants.

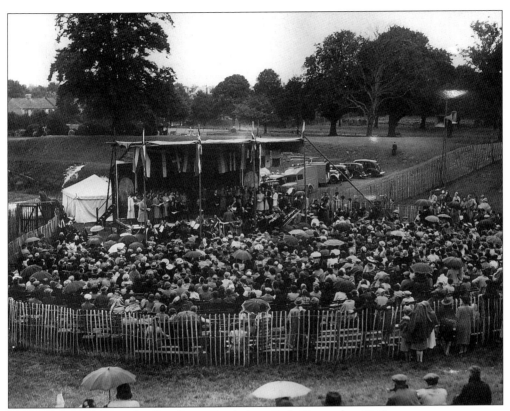

An open air concert in the Hog Pit in Carshalton Park, September 1942.

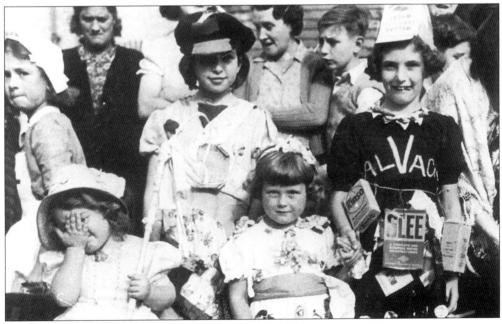

Children at the V.E. Day celebrations, Brambledown Close.

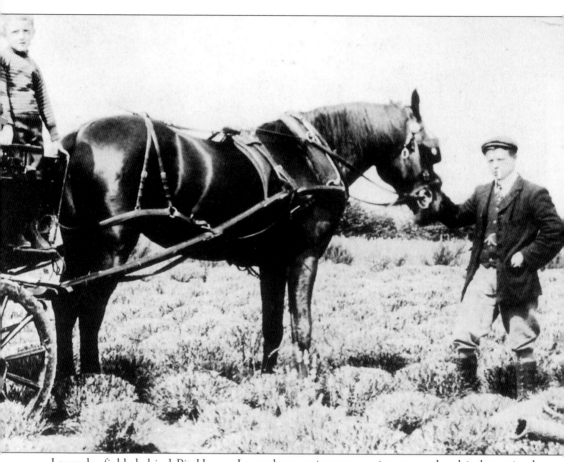

Lavender fields behind Pit House. Lavender growing was an important local industry in the nineteenth and early twentieth centuries. These fields were close to Pit House which stands in an old chalk pit on the west side of Park Hill just north of its junction with Banstead Road.

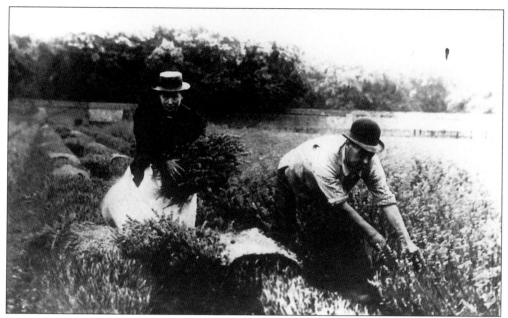

Gathering lavender at Carshalton. The lavender was cut when it was in flower and the oil extracted by distillation to be used in soaps and cosmetics.

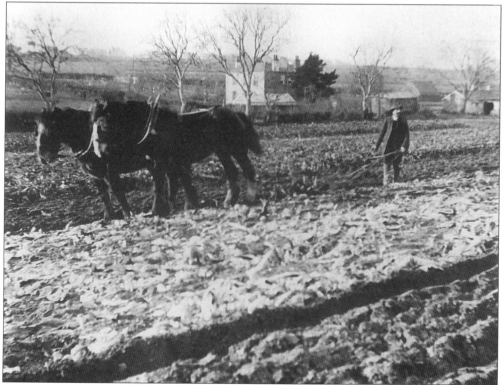

A horse-drawn plough at Barrow Hedges Farm prior to 1923.

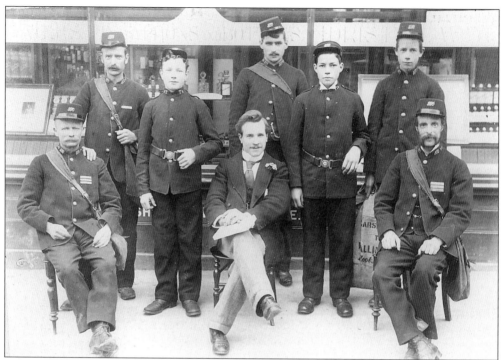

Charles Card, sub-postmaster, and his staff outside Comyn's chemist shop in the High Street, 1897.

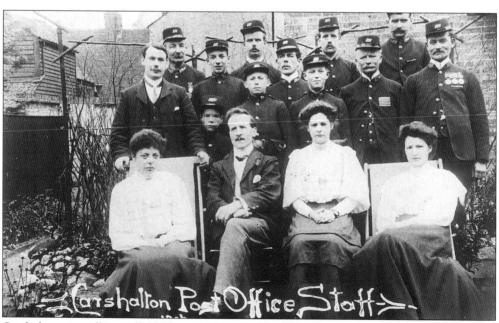

Carshalton post office staff, 1906, now 16 in number. The office had transferred from Comyn's chemist shop to the other side of the road at what is now 22/24 High Street.

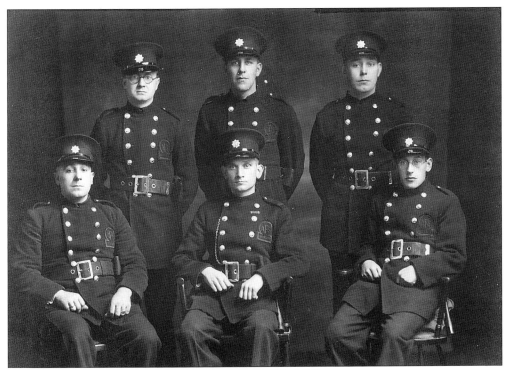

Carshalton Auxiliary Fire Service during the First World War.

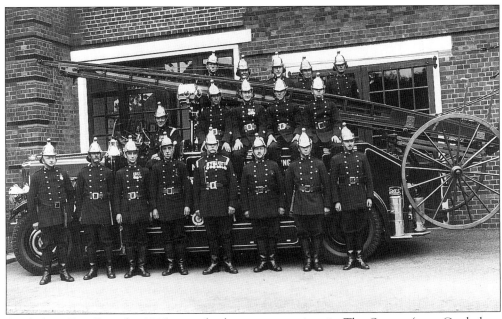

Carshalton Fire Brigade, 1935, outside their new premises in The Square (now Carshalton library).

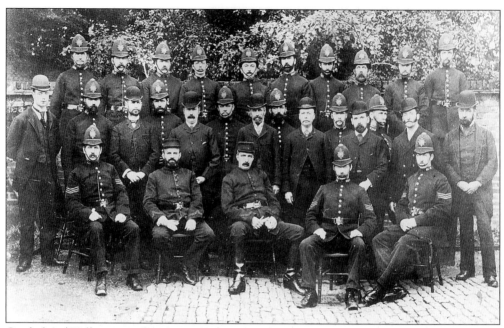

Carshalton/Wallington police force, 1892.

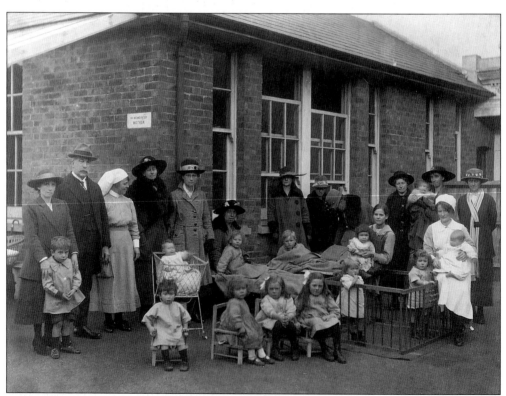

The day nursery which was opened 17 March 1917 in the The Old Cottage Hospital, Rochester Road.

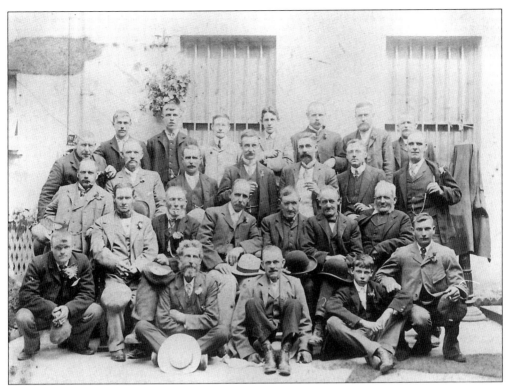

Carshalton Urban District Council
staff, 9 July 1906.

The electricity showroom in the High
Street decorated for the coronation of
Queen Elizabeth, 1953.

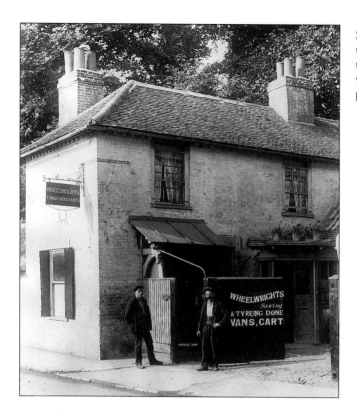

S. Preen, wheelwrights and timber merchants, took over the site of the Old Swan Inn when it ceased trading as a pub around 1909.

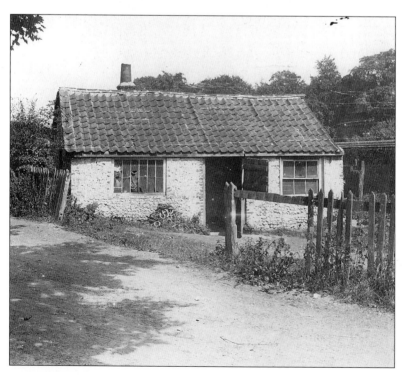

The Old Smithy, Fairlawn Road adjacent to Croydon Lane, c. 1920. Note the discarded horseshoes to the side of the door.

Richard Allen's tailors shop, West Street. The shop, established in 1842, stood on this site for more than 50 years. Allen described himself as 'Accoutrement Fitter to the Third Surrey Rifle Volunteers' in the local directory.

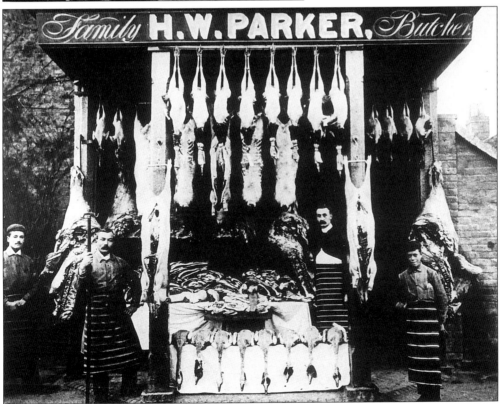

H.W. Parker, family butcher, 11 West Street.

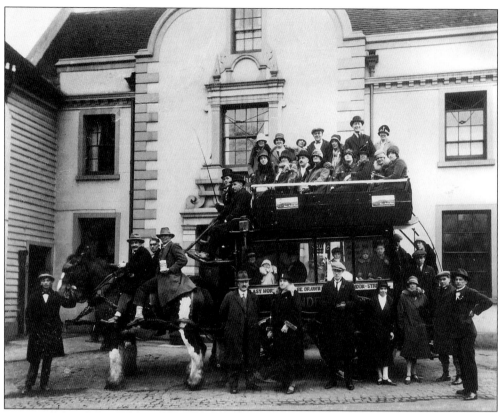

A horse-drawn bus outside the Greyhound with posters asking people to Wear a Flanders Poppy!

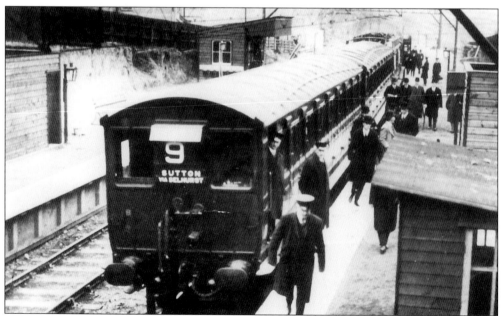

The first overhead electric train at Carshalton Beeches station, 1925.

Two
Wallington

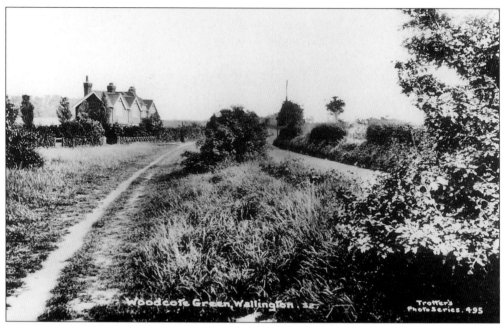

Woodcote Green looking along Woodmansterne Lane, c. 1925.

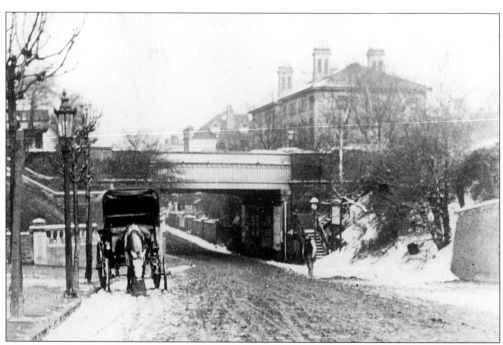

Woodcote Road looking north towards the railway bridge c. 1900.

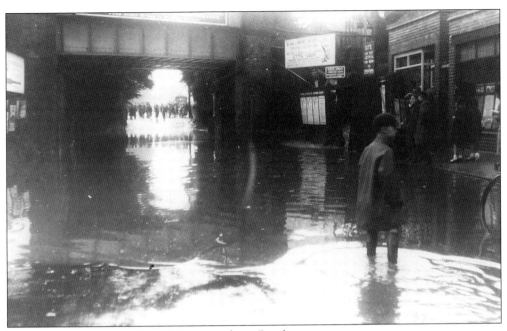

Floods beneath the railway bridge in Woodcote Road.

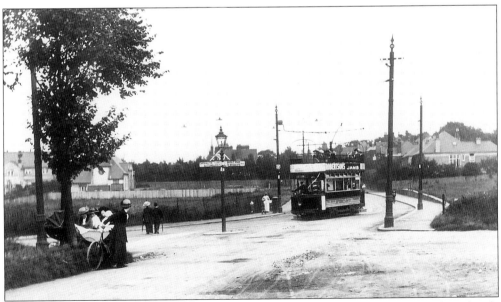

Tram turning from Stafford Road into Park Lane. This photo must have been taken shortly after the tramway was constructed in 1906 and before 1913 as the land around the junction was by then covered with buildings.

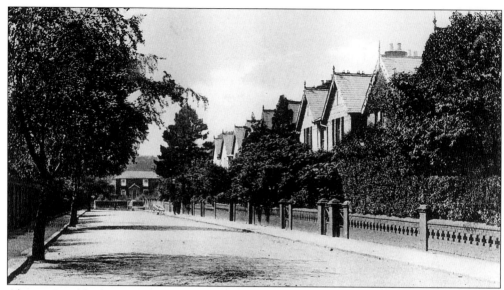

Alcester Road looking towards Manor Road in the late nineteenth or early twentieth century.

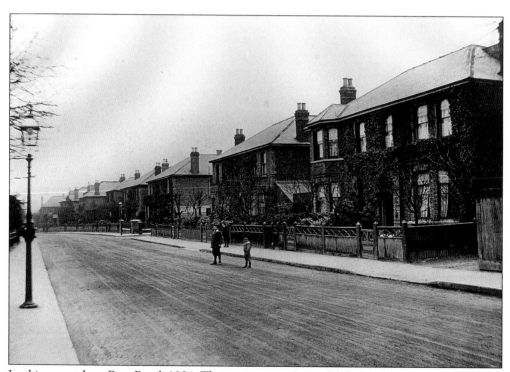

Looking east along Ross Road, 1904. The turning into St Michael's Road is on the right. These houses were probably built in the 1880s when the area near Wallington station was being developed.

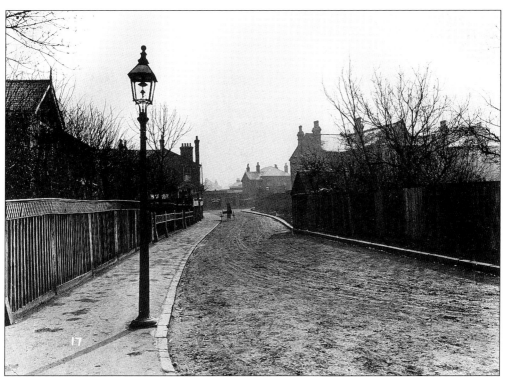

Elgin Road looking south towards Stafford Road, c. 1900.

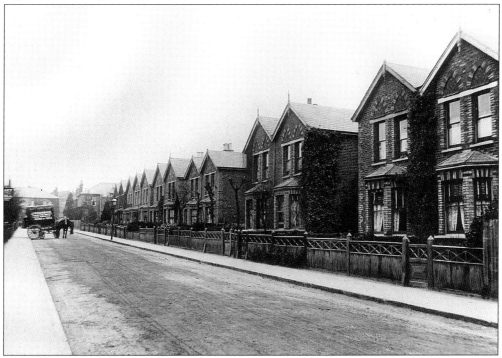

St Michael's Road, 1904. This road was developed in the late 1870s. The houses with gables facing the road are very characteristic of the local area in the mid to late nineteenth century.

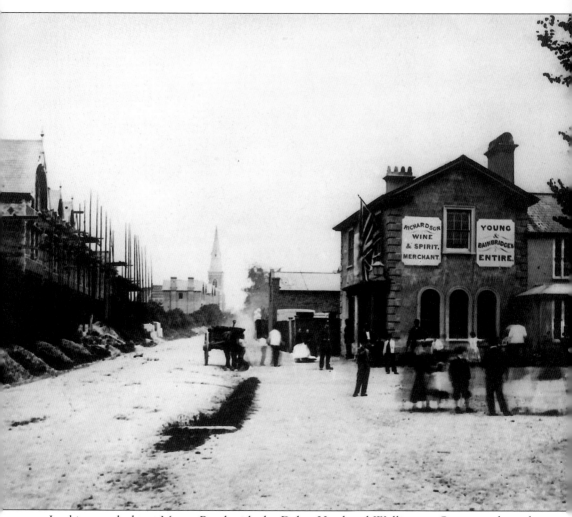

Looking south down Manor Road with the Dukes Head and Wallington Green on the right, *c.* 1870 with the houses on the left under construction. The church in the background is Holy Trinity, built in 1866-7 to serve Wallington when it became a parish in its own right.

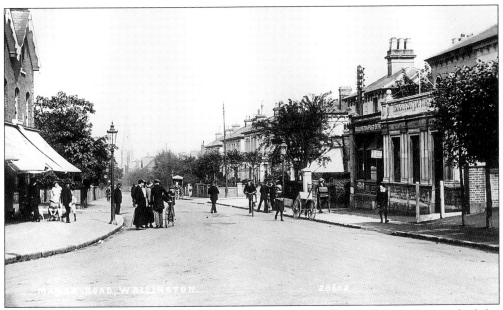

Looking north up Manor Road in the 1920s. The entrance to Station Approach is on the left.

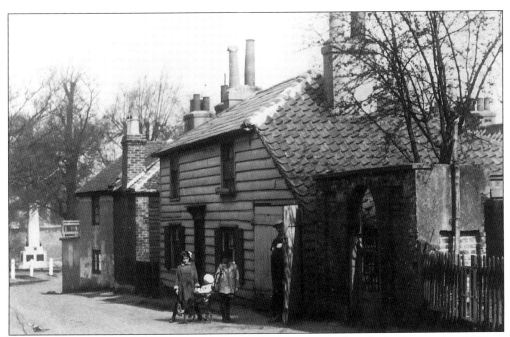

Wright's Row looking towards the Green with the war memorial in the background, *c.* 1927.

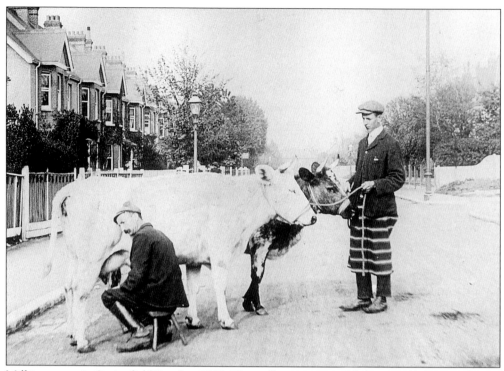

Milking a cow in Springfield Road in 1903. The milk was presumably being sold door-to-door as this was a guarantee of freshness and purity.

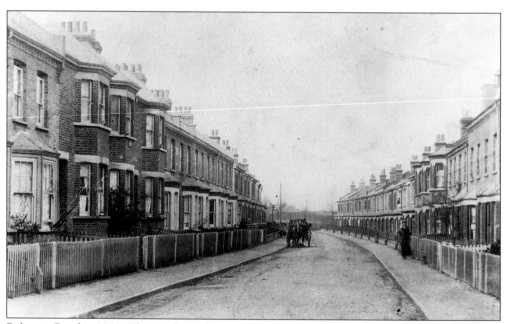

Belmont Road c. 1908. This road was developed in several stages in the late 1870s and 1880s.

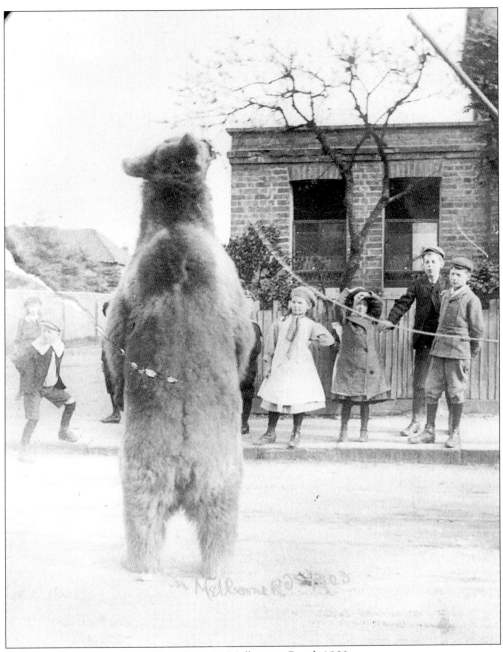

A dancing bear from a travelling show, in Melbourne Road, 1903.

The Hackbridge Triangle, post World War I.

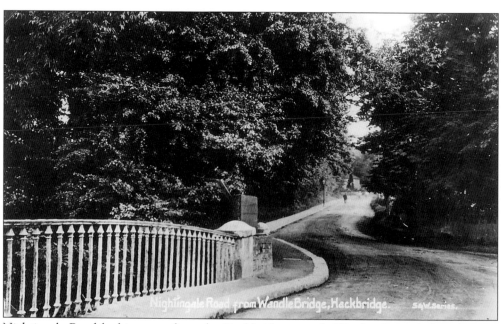

Nightingale Road looking west from the Hackbridge towards Wrythe Green before the iron bridge was replaced in 1912.

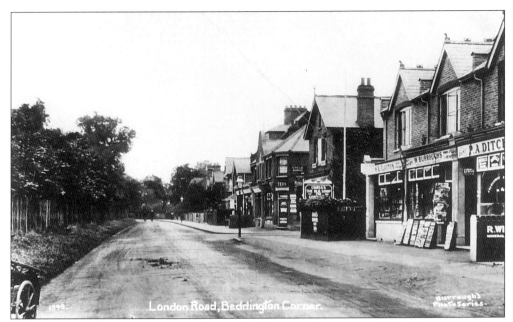

Looking south along London Road near Beddington Corner, *c*. 1915. The turning into Seymour Road can be seen on the right. The trees on the left mark the western edge of the sewage farm.

Mill Green. These cottages were built to house workers from the leather mills which stood by the Wandle near the west end of the Green.

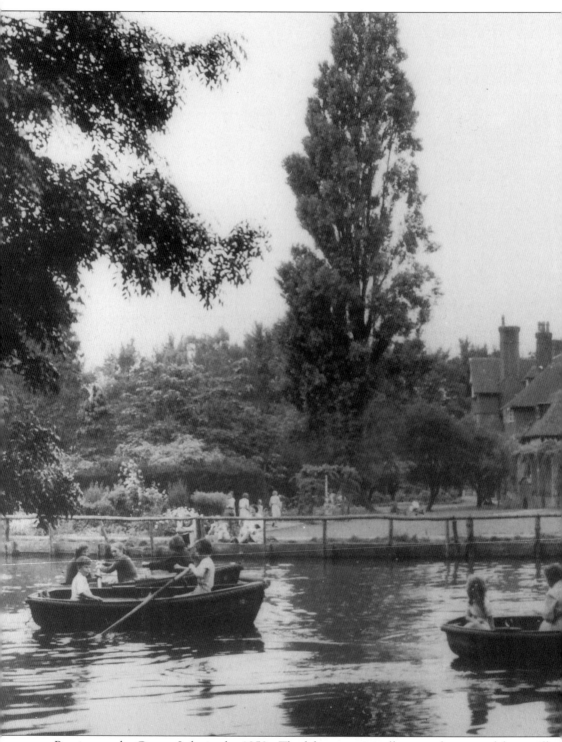

Boating on the Grange Lake in the 1950s. The lake was originally created as a pond for a mill which stood immediately above Wallington Bridge. Boating was introduced in 1936 when the Grange was acquired by Beddington and Wallington Urban District Council and turned into a

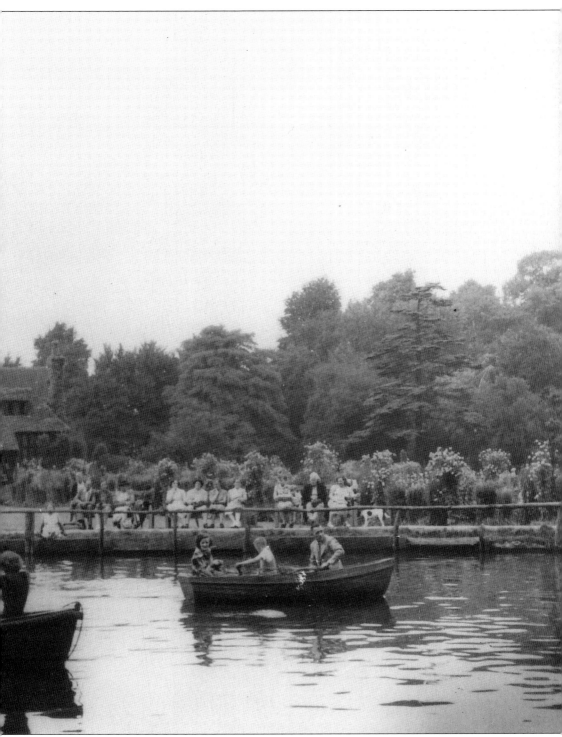

public park. The council ceased operation of the boats in 1975 but they have recently been reinstated.

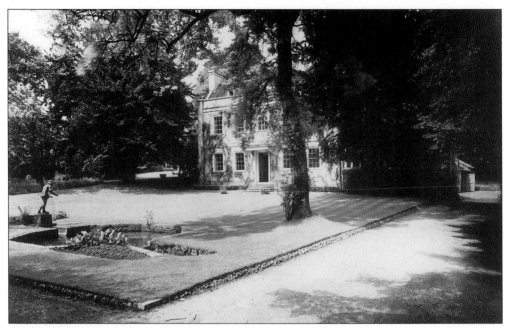

Wandle Bank. This is the only one of Wallington's large houses to have survived. The present building dates from the late seventeenth or early eighteenth century although there has almost certainly been a house on the site for much longer. The house was owned by the pre-Raphaelite painter Arthur Hughes from 1876 to 1891 who added a studio to the north end of the building.

The first 'Hackbridge' was probably a medieval packhorse bridge. The bridge shown here was built around 1800, a little downstream of its predecessor, and was constructed of cast iron. The County Surveyor initially refused to certify it because the properties of iron bridges were not yet sufficiently known but it lasted until 1912 when it was replaced because of the increasing volume and weight of traffic.

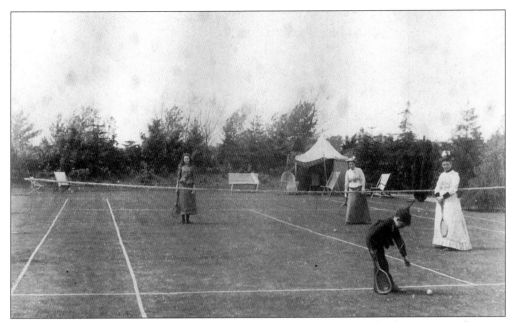

The tennis court at Sunnybank, Woodcote Road, c. 1895. Sunnybank was torn down in 1934/35 to make way for the new Town Hall and library.

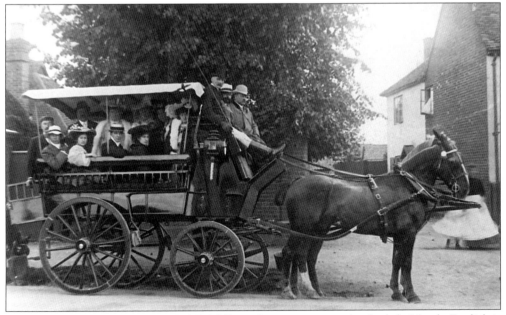

On route to Ascot races, c. 1908. Mr Millest, the grocer, is on the far left; Maude Fosdick is sitting near the front (in a frilly hat) and her father is next but one to the driver.

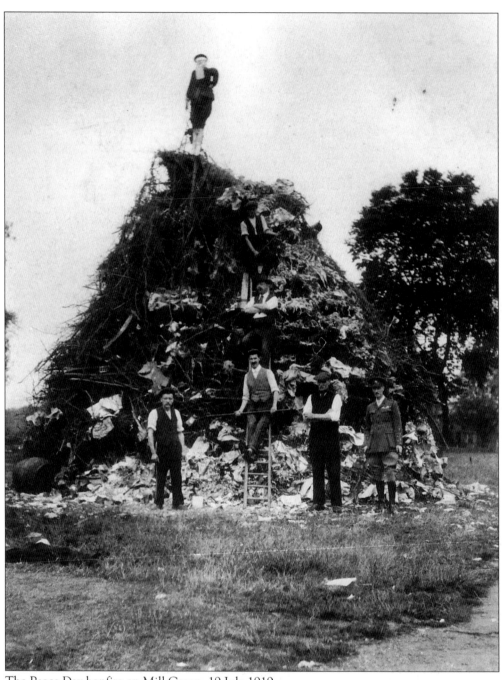

The Peace Day bonfire on Mill Green, 19 July 1919.

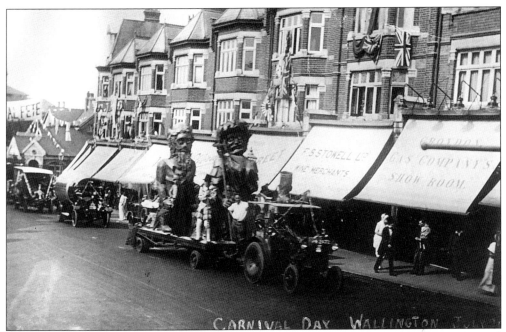

Carnival floats passing along Woodcote Road, 27 July 1929. The railway bridge is just beyond the left side of the photo.

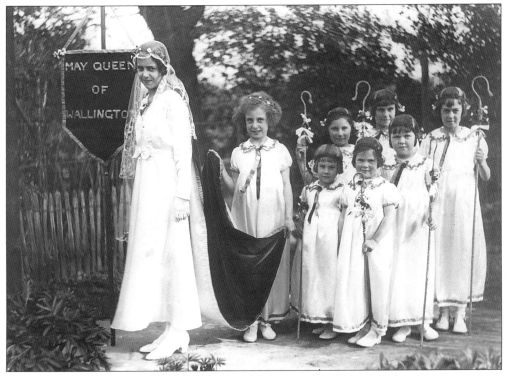

Miss Iris Watts, Wallington May Queen.

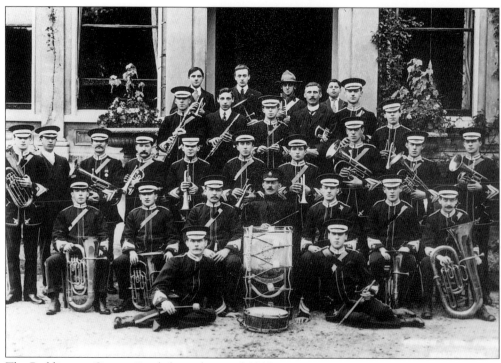

The Beddington Corner Band, formed around 1912.

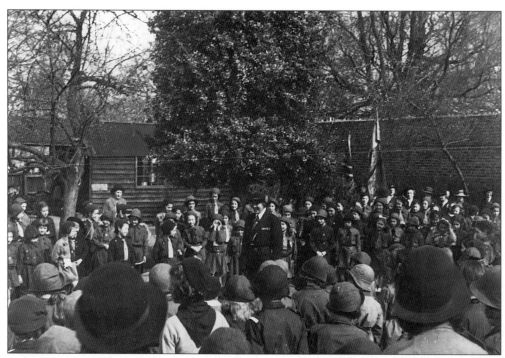

Lady Baden Powell visiting the Guides' hut, at the south west corner of Wallington Green. It was demolished by a V1 in 1944.

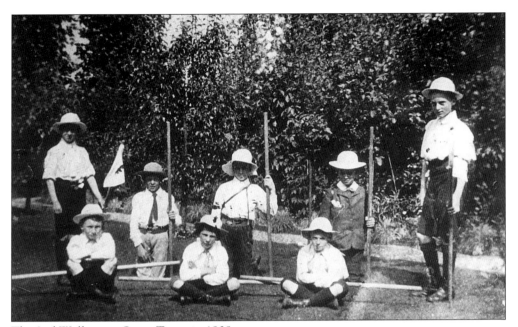

The 2nd Wallington Scout Troop in 1908.

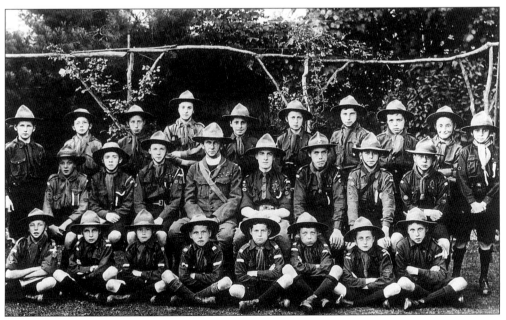

The same scout troop, *c.* 1912.

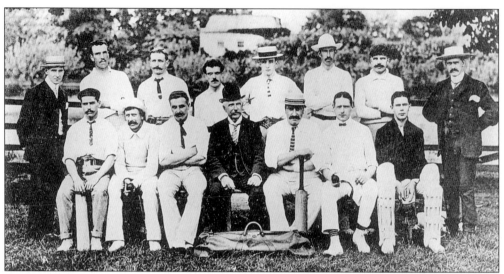

Wallington Athletic cricket club, 1905.

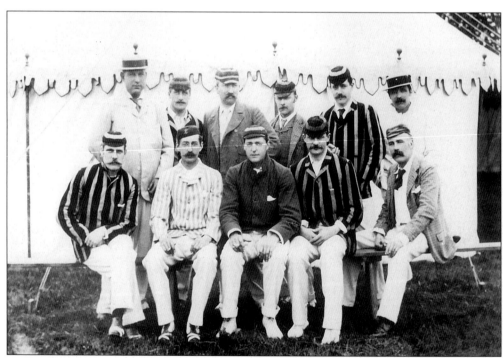

Wallington House of Commons cricket team early this century.

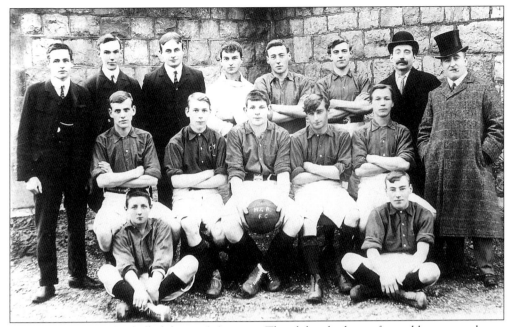

Mill Green Rovers football club, 1905-6 season. The club, which was formed by excess players from Beddington Corner, played on the common opposite Tramway Terrace. Mr W. J. Webber, president, is on the far right of the photo.

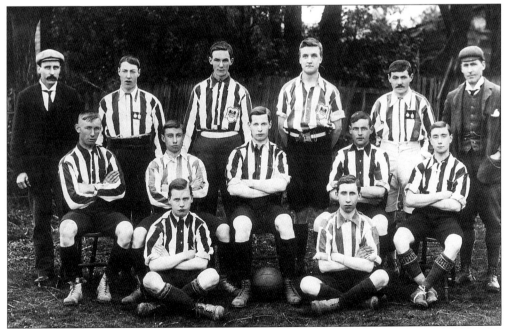

Beddington Corner football club reserves, 1901-2 season. The team played in a field by the railway. During this season they played 20, won 9, drew 7 and lost 4.

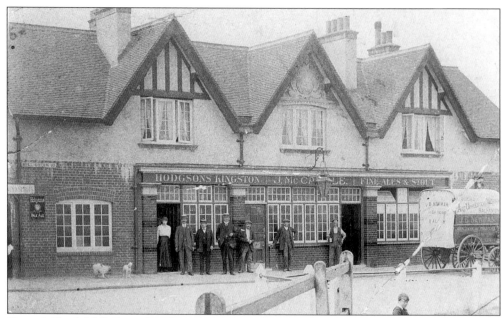

Queen's Head, Mill Green Road, *c.* 1910. This pub, erected at the turn of the century, is at least the third on site, there being evidence of an alehouse called the Queen's Head in 1776.

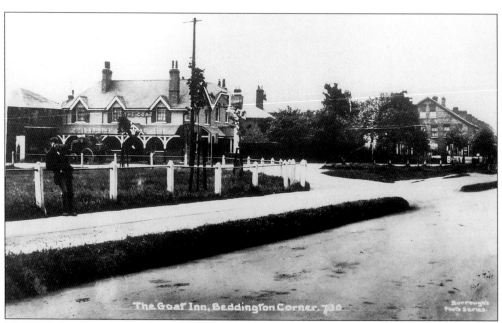

The Goat Inn at Beddington Corner, early this century.

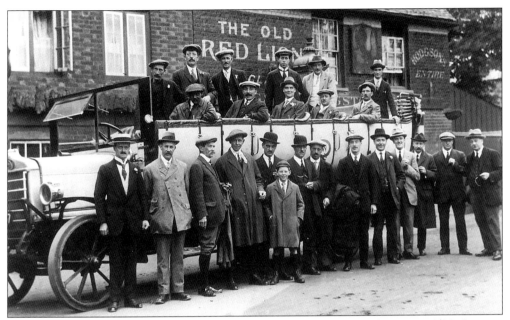

A pub outing from the Old Red Lion (now the Red Lion), Hackbridge, *c.* 1919/20. Prior to 1914 the inn used to open at 6 o'clock in the morning to serve coffee and rum to the leatherworkers at Shepley Mills, Hackbridge.

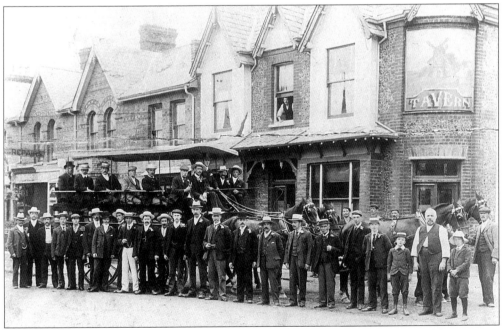

Another outing, this time from the Windmill, Stafford Road, around the turn of the century. The Windmill was built in or just before 1872 and took its name from a smock mill (a windmill with a timber tower) which once stood about fifty yards south of the inn until it burnt down in 1852.

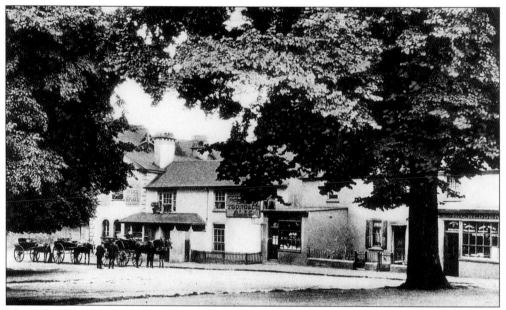

The Duke's Head, Wallington Green. There has been a pub on this site for several centuries. In 1806 the inn was described as a 'low thatched cottage of two rooms only'. The building seen here is thought to date from about 1830 and had stables attached to it.

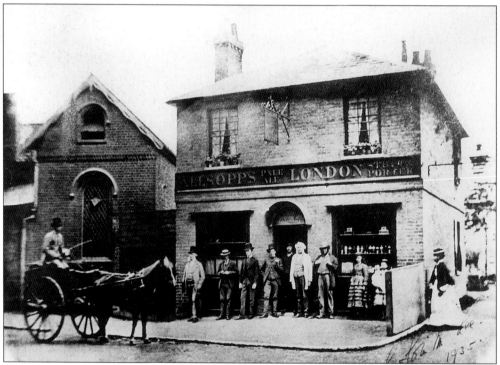

The Rose and Crown, London Road at the junction with Butter Hill. The pub was established around 1870. The name over the door is Charles Mawer who is known to have been the licencee in the late 1870s and early 1880s. He also operated a bakehouse at the rear of the building.

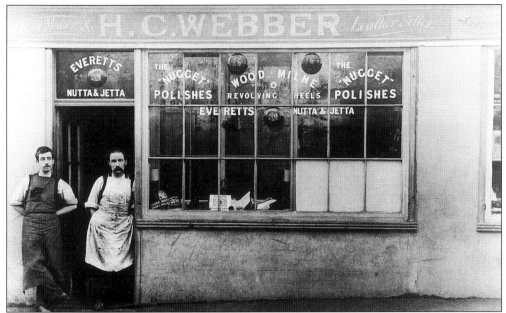

H.C. Webber, bootmaker and leather seller, 4 Wallington Green, 1908. Horace Webber is standing on the right and a Mr. Bill Greenway is on the left. The shop stood on the south side of Wallington Green to the west of the Dukes Head. It was destroyed by a flying bomb during the Second World War.

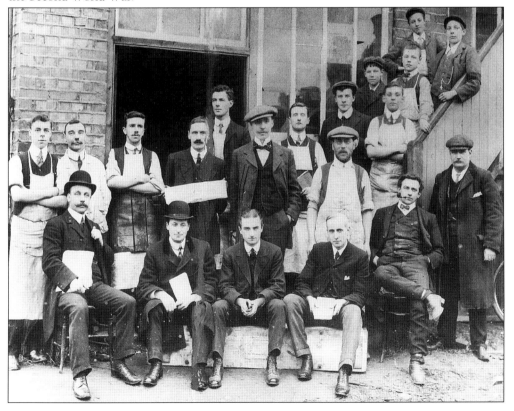

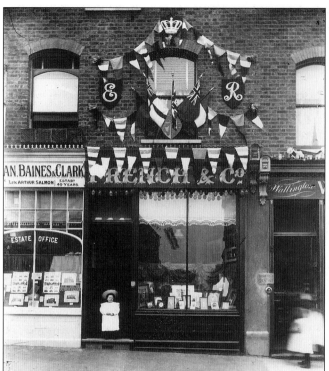

French & Co. studio, Railway Terrace, Manor Road, decorated for the coronation of Edward VII in 1902. Harry J. Kempsell ran French and Co. from around 1893. The name of the shop was that of an aunt who financed the business.

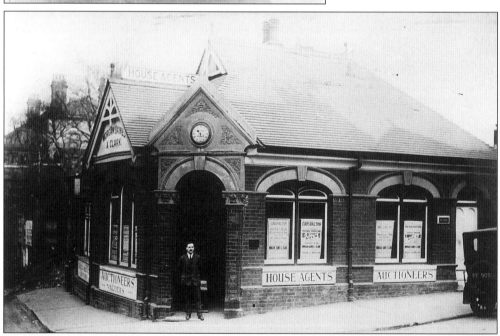

The offices of Morgan, Baines and Clark, auctioneers and estate agents at the corner of Woodcote Road and Ross Parade. John Morgan, 'printer, bookseller and house agent' is listed in the earliest Sutton directory which he published himself in 1864. The business had become Morgan, Baines and Clark by 1897. They opened an office in Railway Terrace, Wallington around 1902, but soon moved to this location.

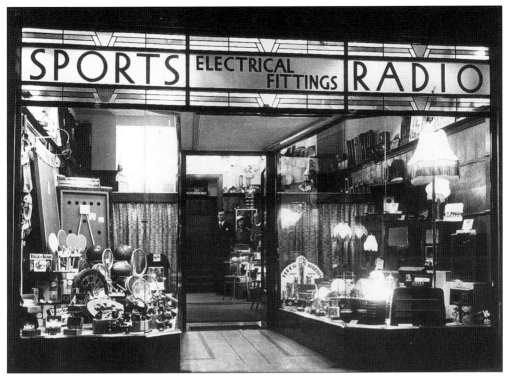

H.W. Burnett sports and radio shop, 53A Woodcote Road. The shop is not traceable in the series of street directories which end in 1938. The shop front is, however, in the 1930s art deco style.

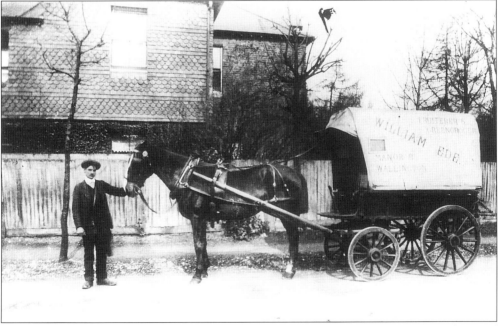

William Ede, 1869. In those days the business was only a horse and cart carrying fruit and vegetables.

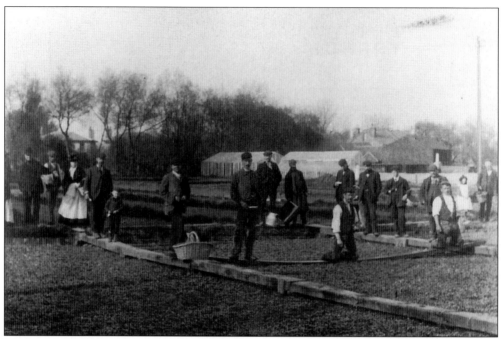

The watercress beds on the east side of the Wandle at Beddington Corner in the early twentieth century. The rear of the houses along Mill Green Road can be seen in the background.

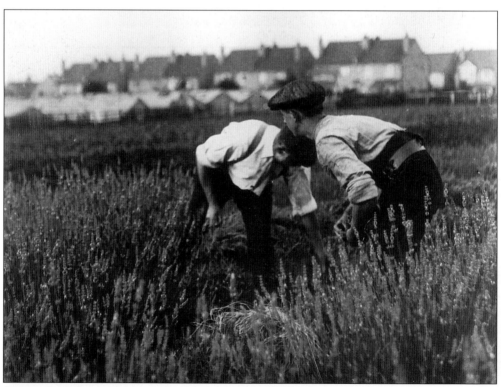

Cutting lavender on the east side of Sandy Lane in 1913.

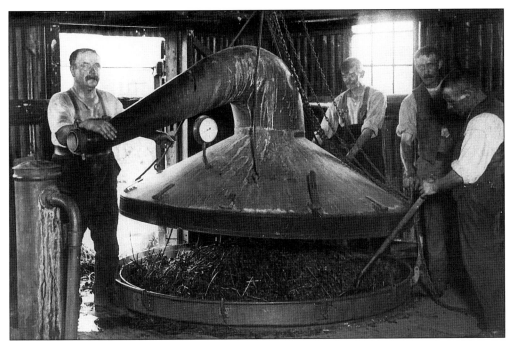

Retort at Miller's distillery which was located to the south of Mill Green Road, Beddington Corner.

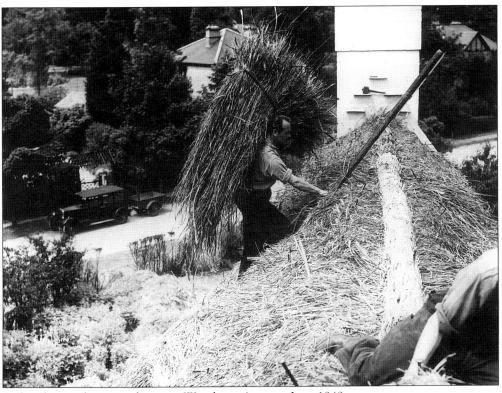

A thatcher working on a house in Woodcote Avenue, June 1949.

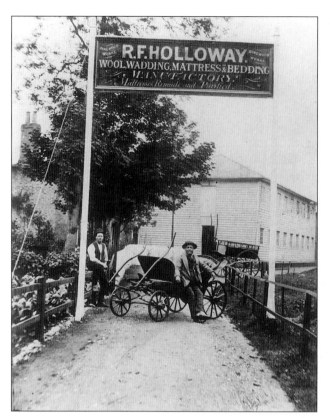

The entrance to Holloway's wool, wadding, mattress and bedding factory, 1880. This stood on the west side of London Road, a short distance north of the Wandle. The business appears to have been established by 1843 and last appears in the local directories in 1921, when it was probably meeting strong competition from mass-produced furnishings.

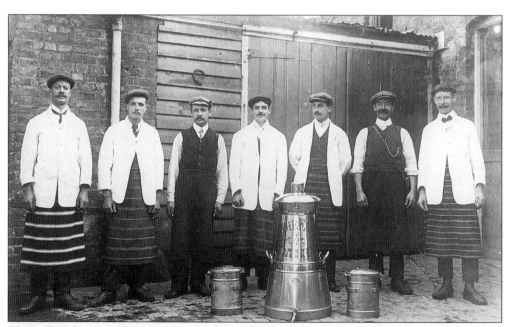

The staff of the Home Farm Dairy, which stood at the corner of Stafford Road and Clyde Road, in 1909.

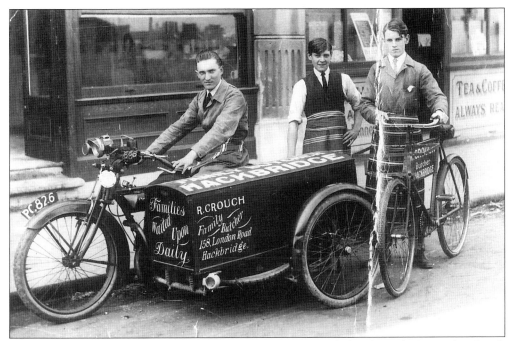

Motor cycle and bicycle used for delivery by R. Crouch, family butcher of 158 London Road, Hackbridge.

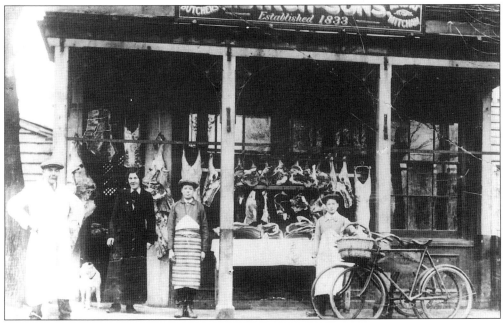

E. Birch & Sons, butchers, of Beddington Corner.

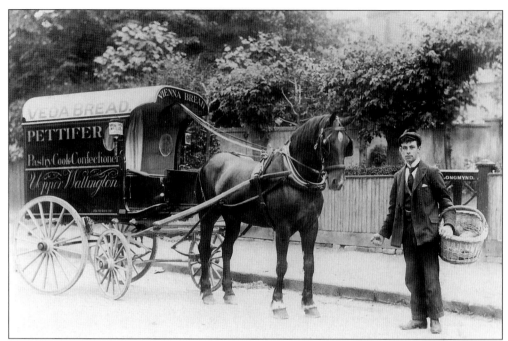

Delivery cart for W. Pettife, baker, pastrycook & confectioner of 1 Fortescue Terrace, Stafford Road.

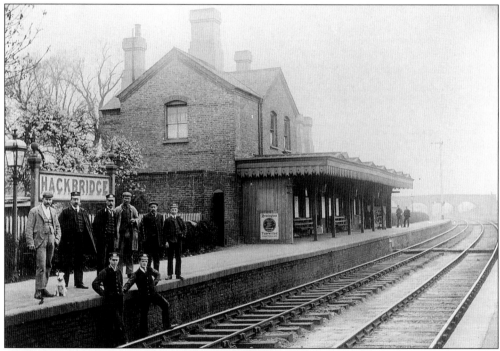

The staff at Hackbridge station in 1890. This shows the line before it was electrified in 1929. The main signal is set high so that the engine driver could see it as he approached. The lower signal is a repeater which was easy to see when the engine was standing at the end of the platform.

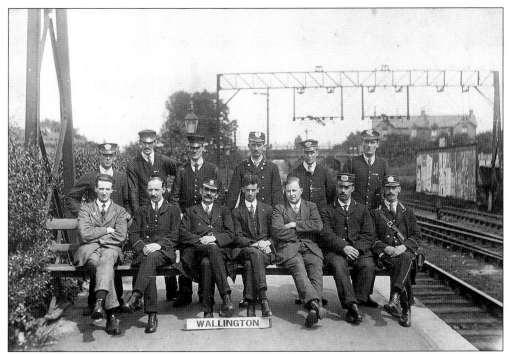

Wallington station staff, 1918. Work at the overhead power lines started in 1913. They were replaced by the present third rail systems in 1927-8.

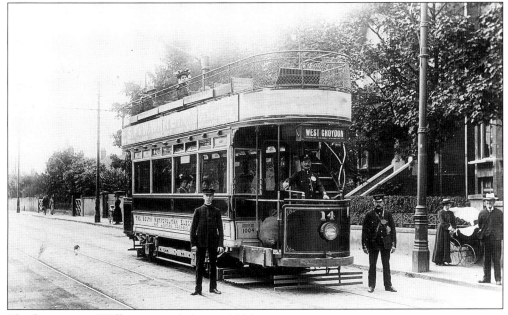

The first tram at Wallington on 8 August 1906.

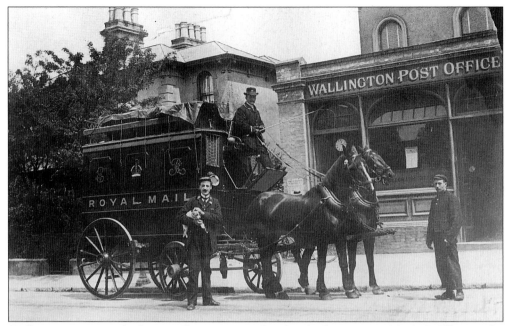

Wallington's purpose-built post office in Manor Road early this century. Mr A.G. Ellis was the postmaster at this time.

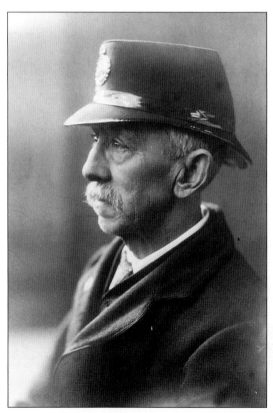

Mr. William Boggis of Orchard Hill, Carshalton, an auxiliary postman at Wallington in the early 1920s.

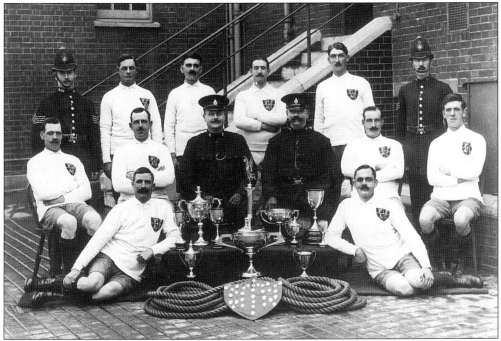

Wallington police tug of war team in 1919. From left to right, back row: Stn. P.S. Spall, P.C. Bell, P.C. Hemsley, P.C. Martin, P.C. Barford, P.S. Kerby; middle row: P.C. Dodd, P.C. Rattray, Chief Insp. Clark, Sub. Div. Insp. Kelly, P.C. Corden, P.C. Jackson; Sitting: P.C. Frost and P.C. Pinnix.

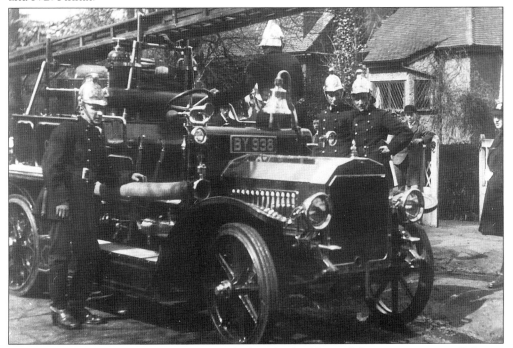

The old Wallington fire engine, c. 1931, before the building of the new station in Belmont Road.

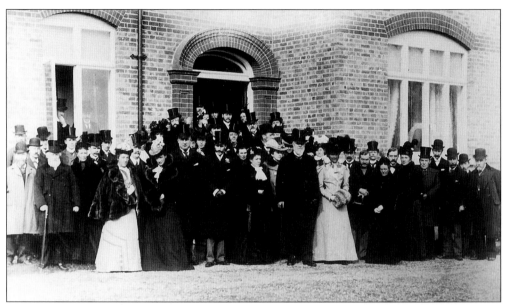

The opening of the Wandle Valley Isolation Hospital in 1899.

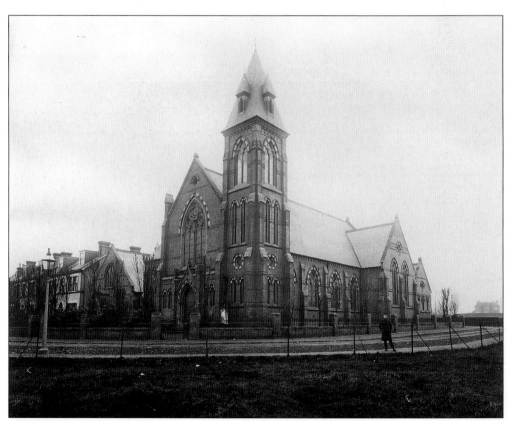

The Baptist church, Queens Road. The original congregation of 22 first met in 1876 in Carshalton Public Hall. The church in Queens Road was opened in 1888.

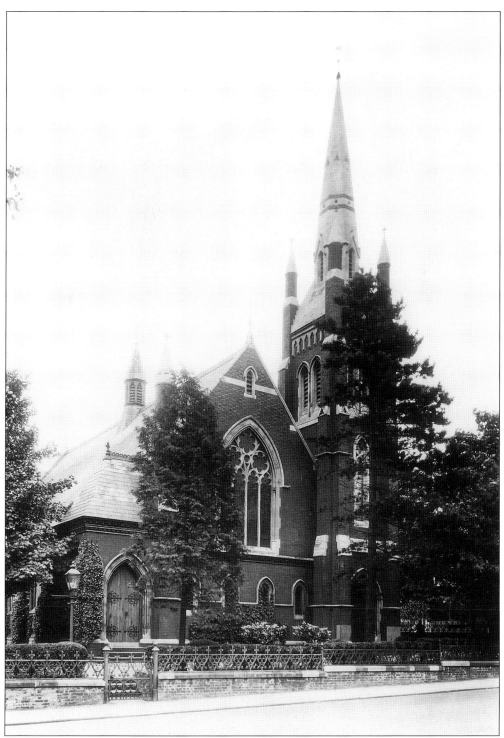

Christ Church Presbyterian church, before it became a United Reformed church. Built in 1887, it closed down in 1987 when the congregation merged with the neighbouring United Reformed church in Holmwood Gardens. It was finally demolished in 1992.

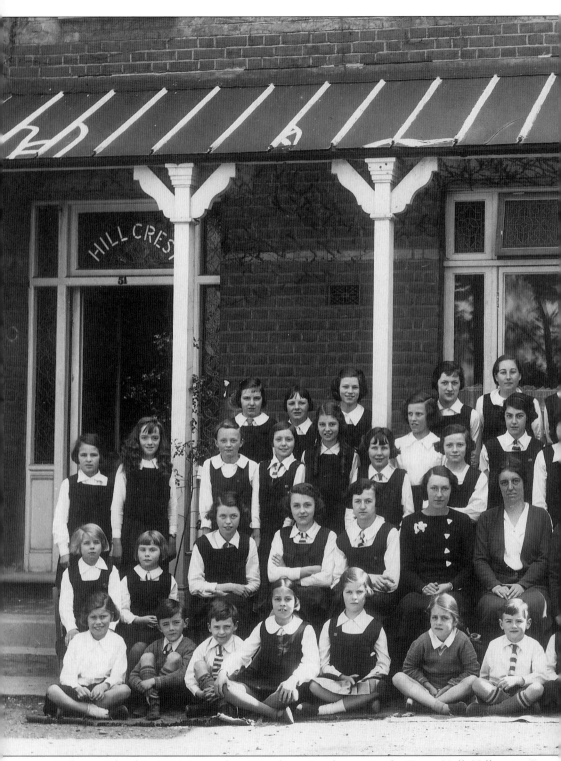

Hillcrest School in 1934. Located on Woodcote Road opposite the Town Hall, Hillcrest was a private school for girls. Mrs Pennington-Collings was the head at this time.

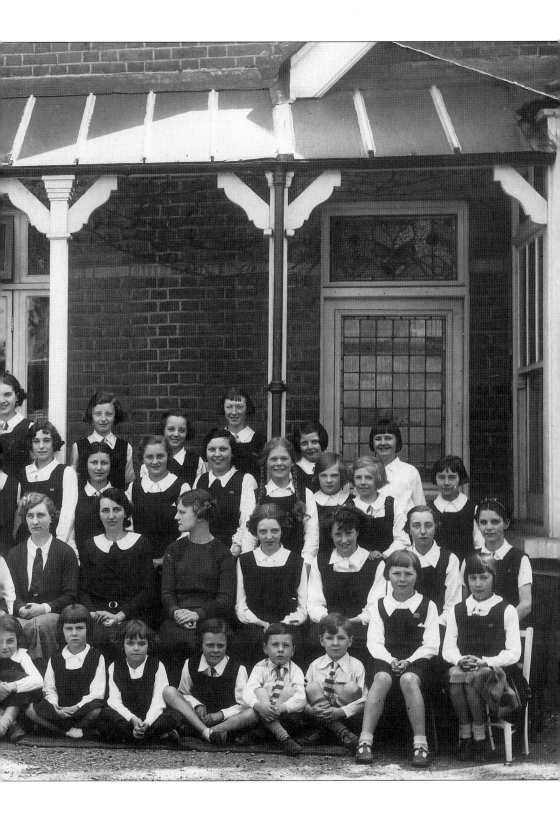

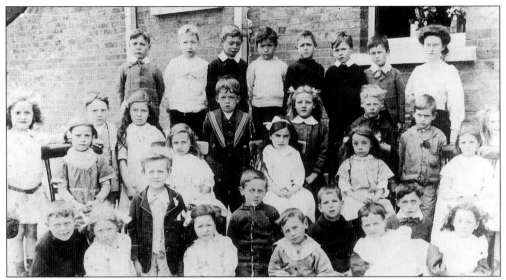

The pupils of Bandon Hill School, *c.* 1914. The teacher is Miss Clarke who began as a pupil-teacher in the 1890s and stayed 52 years.

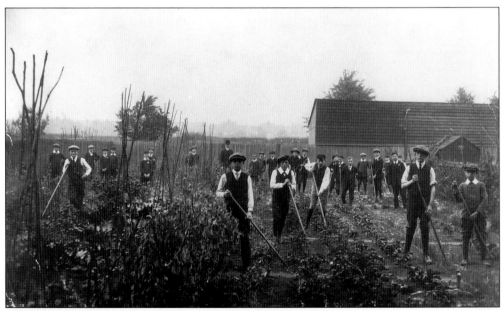

Bute Road School, when gardening was part of the curriculum.

Three
Beddington

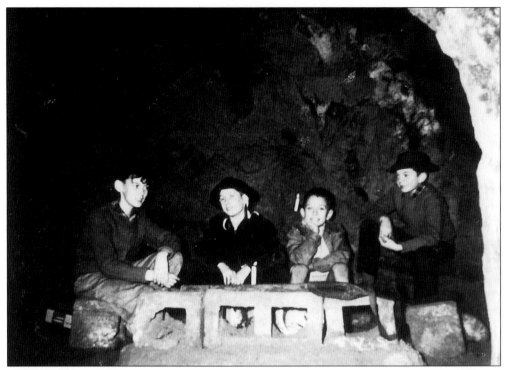

Inside Beddington Caves, c. 1959. The caves, of unknown origin, were located in a bank of Thanet sand opposite The Plough public house. Having become unsafe they were closed in May 1932, but have since been open from time to time.

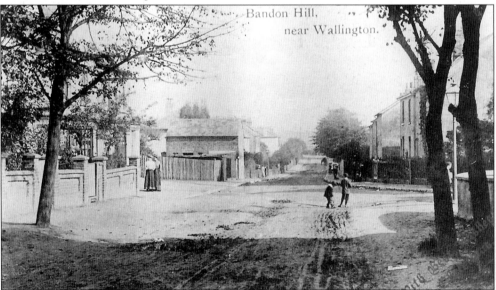

Bandon Hill, c. 1900. When this view was taken the road was called Beddington Grove and was part of a small, rather haphazard development which lay south of the West Croydon - Sutton railway and west of Plough Lane. The road is now called Sandy Lane North and the view looks east towards its junction with Plough Lane which can be seen in the distance.

The old thatched barn which stood at the junction of Croydon Road (left) and Hilliers Lane (right) was used for many years by Dawson and Sons, builders, contractors and undertakers who also manufactured coffins. It was demolished around 1935. Although the junction has changed beyond recognition, the house to the left still stands.

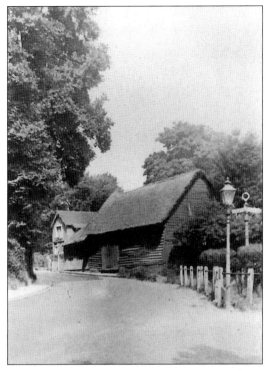

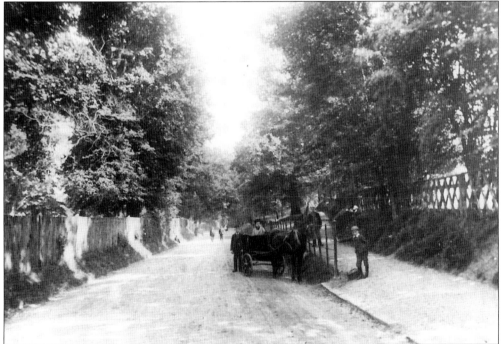

Sandhills (Croydon Road today), c. 1907, looking east from a point near the junction with Church Road and Demesne Road. The fence on the left is the boundary of a field called Church Paddock which is now part of Beddington Park. The path on the right is starting to climb up towards Queen Elizabeth's Walk.

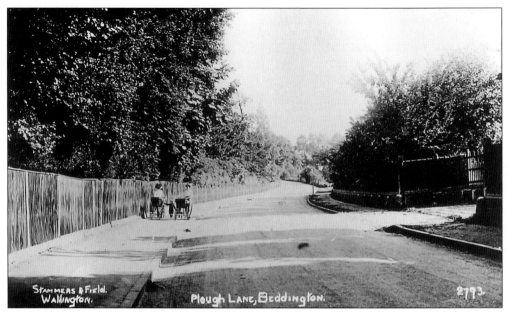

Plough Lane, from a postcard dated 1915. The view looks south towards the railway bridge with the entrance to Bandon Hill Cemetery on the right.

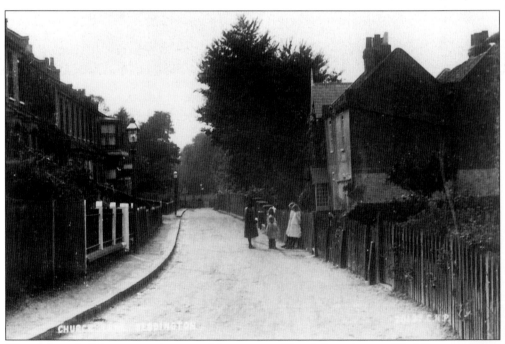

Church Lane looking west at the turn of the century. Church Lane is one of Beddington's oldest roads, thought to date back to the Middle Ages, though most of the houses along it date from the late nineteenth or twentieth century.

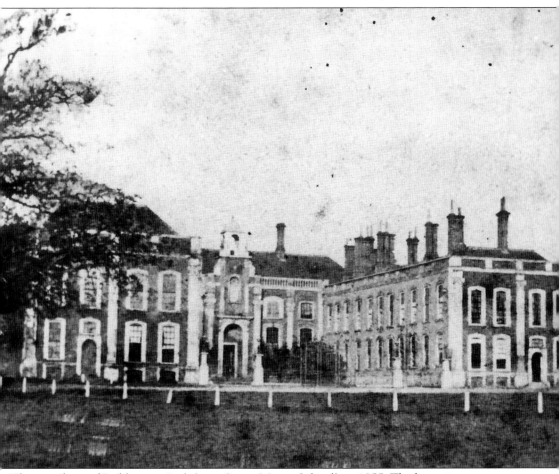

The west front of Beddington Park (now Carew Manor School), *c.* 1855. The last private owner was Charles Hallowell Hallowell Carew who, in 1859, was forced to sell it and his other estates to pay his gambling debts. The building was acquired by the Lambeth Female Orphan Asylum who gave the building much of its modern appearance.

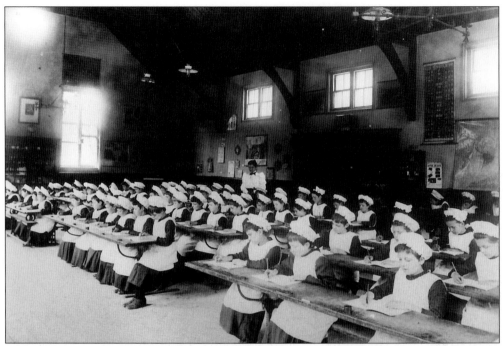

Classroom at the Royal Female Orphanage, late nineteenth century.

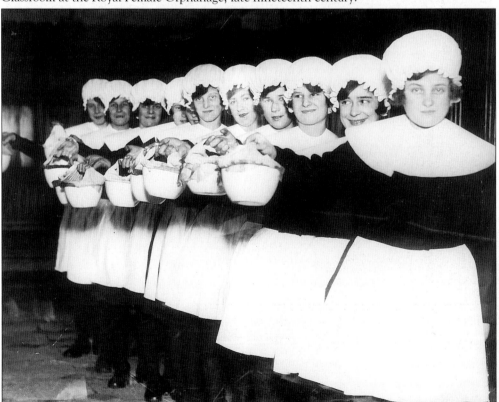

Making Christmas puddings at the Royal Female Orphanage, *c*. 1930.

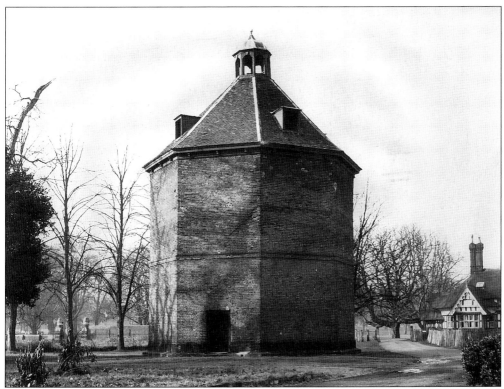

The Dovecote at Carew Manor, 1951. One of the outbuildings of Carew Manor, it was erected at the beginning of the eighteenth century and originally had nesting boxes for over 1,200 pigeons which were killed and eaten as a delicacy.

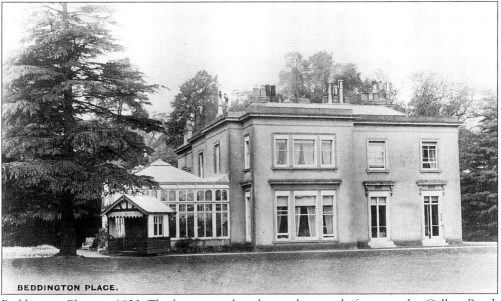

BEDDINGTON PLACE.

Beddington Place, *c.* 1920. The house stood to the southern end of present-day Collyer Road. Built between 1848 and 1868, it was acquired in 1919 by George Payne & Co, then let for a time as a convalescent home, before being demolished in 1928.

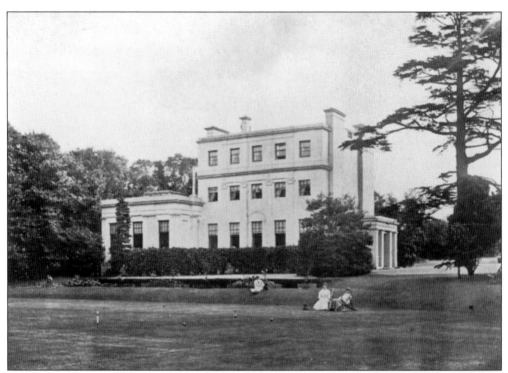

Brandries Hill House, now Camden House, in 1906. Its most notable occupant, from 1790-1809, was Sir Francis Baring, founder of Barings Bank.

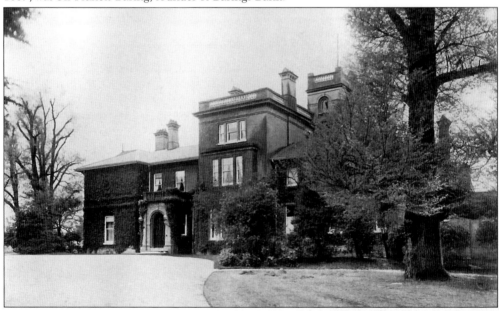

Queenswood in 1914. Situated south of the present Sandhills and backing onto Queen Elizabeth's Walk, it is thought to have been built by a member of the Watney brewing family in the 1860s, but had a relatively short lifespan of only 60 years. As with Beddington House, Queenswood was requisitioned and occupied by the Royal Flying Corps during the First World War.

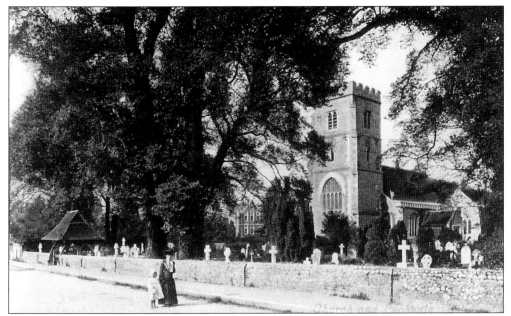

St Mary's church and lychgate. The church shown here was a product of two major periods. The tower, nave, south aisle and Carew chapel (on the far right) date from the late fourteenth and early fifteenth centuries. The church was heavily restored in the nineteenth century when the tower was heightened and various extensions added to the north side. The whole interior was redecorated in the Arts and Crafts style.

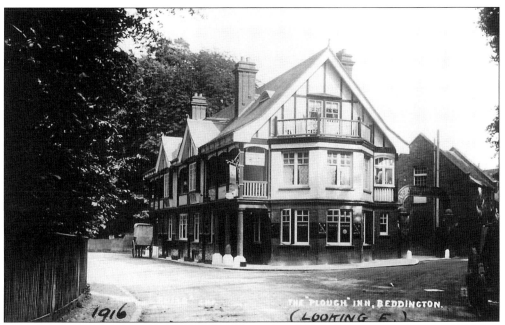

The Plough Inn, at the junction of Croydon Road and Plough Lane, seen here in 1916, has been the site of a pub since the eighteenth century and possibly for much longer. The present building was erected in 1897-8 at a cost of £5516 for building and £305 for J.T. Barker, the architect.

The Harvest Home public house outing, 1895. Established 1860, it was refronted and modernised soon after this photo was taken.

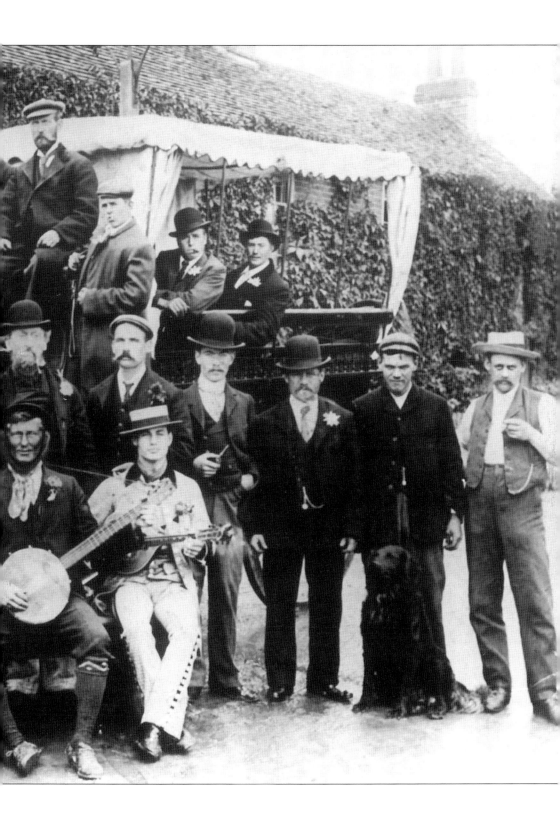

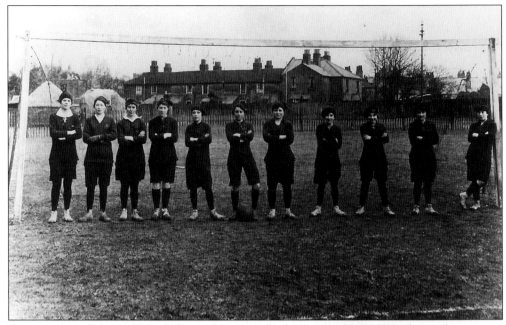

Women footballers, possibly on Goose Green, at the back of Richmond Road.

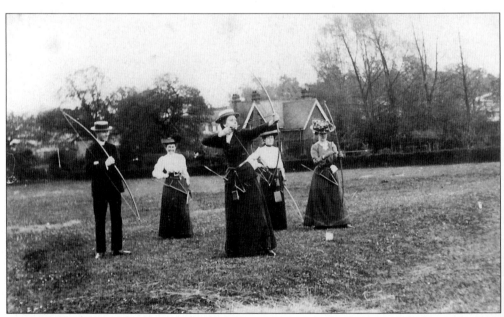

Archery contest between Kent and Surrey at Beddington in 1908. Canon Bridges was, for many years, patron of the Archery Society founded in 1875. His son, John Henry, won the Archery Open Championships in 1905.

100

Cricket pavilion, Beddington Park, *c*. 1910. This was the first pavilion, built around 1880 by Canon Bridges, for the archery and cricket societies.

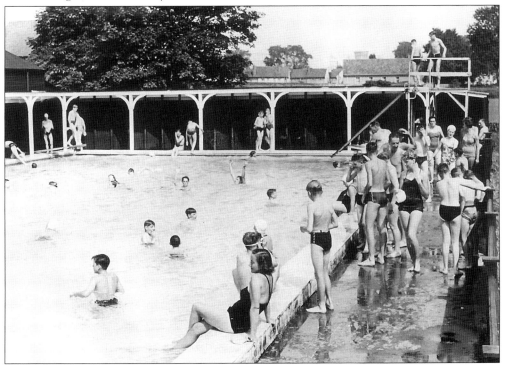

The open-air swimming pool behind Carew Manor, 1956. It was closed after the 1960 season as it had become a threat to public health.

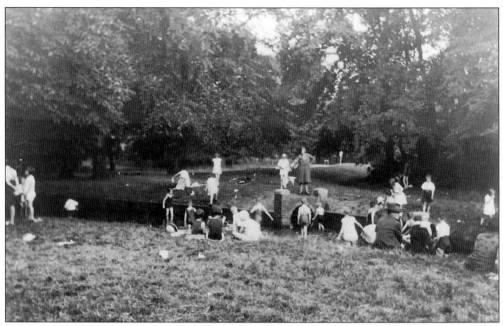

Children playing in the Wandle, Beddington Park. The end of Church Road can be seen in the background.

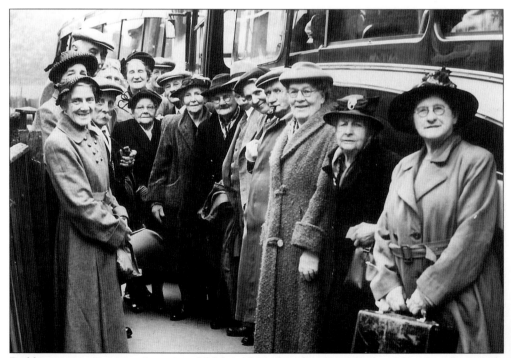

Beddington senior citizen's outing, 25 May 1955. Bert Petchey, the local butcher, frequently arranged summer outings for local residents.

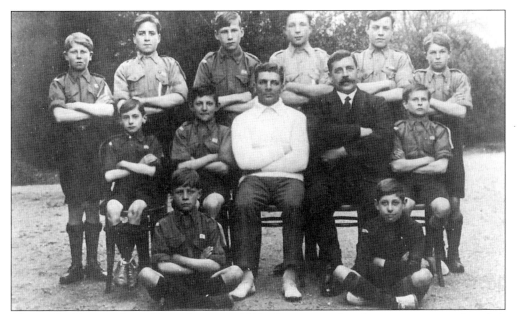

The 1st Beddington Scout Troop began in 1911, three years after the movement was founded. Officially registered on the 15 May 1920, it holds the honour of being the oldest scout troop in the district.

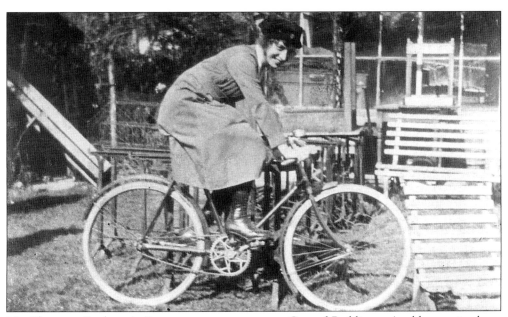

Mrs Florence Coole, née Bown as a young woman. One of Beddington's oldest native-born residents and an enthusiastic cyclist all her life, she died in 1993 at the age of 98.

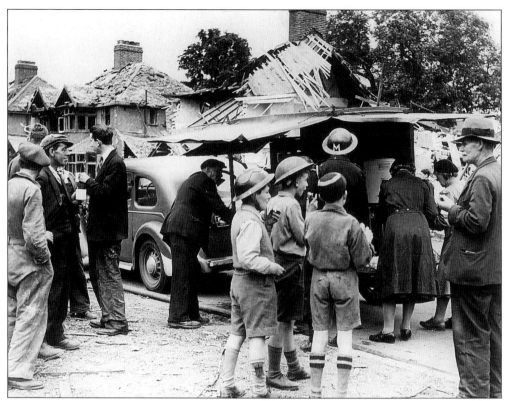

Bomb damage in Croydon Road, 16 June 1944. Note the mobile unit serving hot drinks, probably staffed by the Women's Voluntary Service.

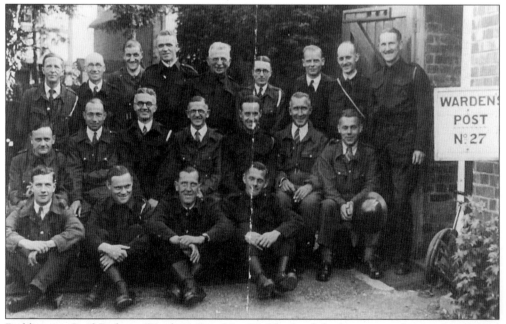

Beddington Civil Defence Warden's Post No. 27. The brick-built post stood in an ornamental garden area at the west end of what is now the triangular green adjacent to the hall.

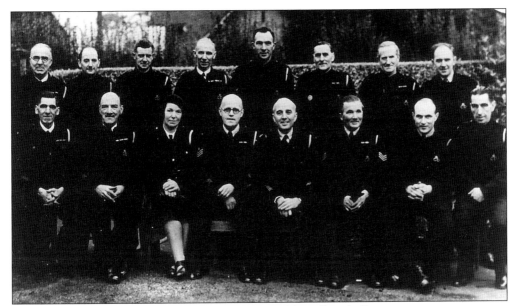

Beddington Air-Raid Wardens (1939-45) in front of the village hall.

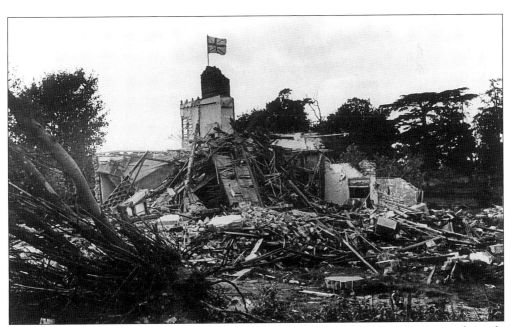

'The Cottage', 67 Guy Road, demolished by a flying bomb, 1 July 1944. No. 67 was formerly known as Ferrers Cottage after the daughters of the Revd. John Bromfield Ferrers, former Rector of Beddington, who lived there. It stood downhill from the old post office which was damaged by the same bomb.

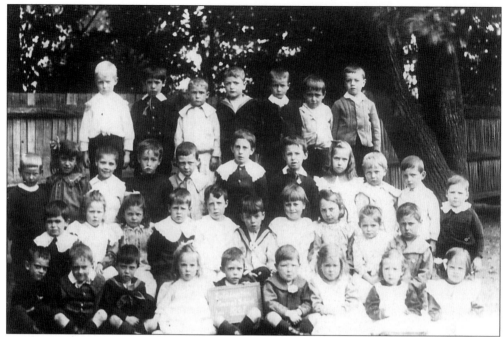

Beddington Central School, 1905.

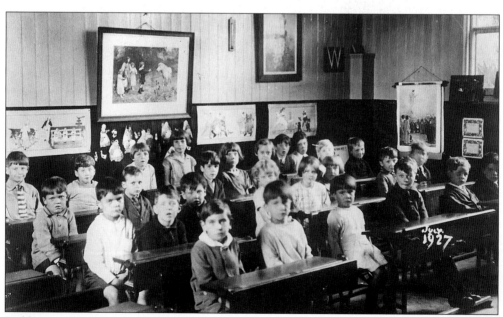

Beddington Central School in 1927.

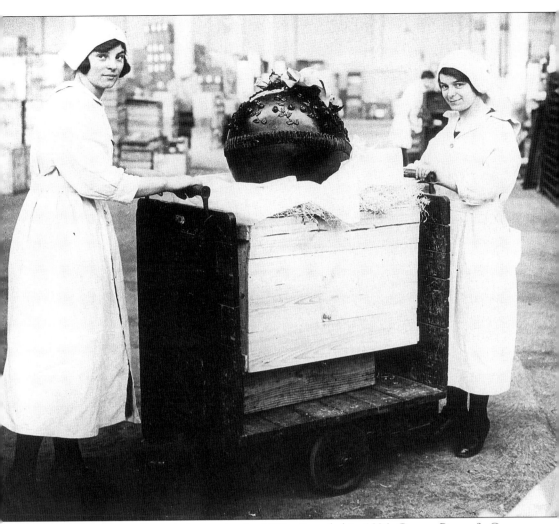

Speciality Easter Egg at Payne's factory in the 1920s. Founded in 1896, George Payne & Co. moved to the Beddington Place estate in 1919 and the factory at Waddon was built for the manufacture of chocolate confectionery in 1921.

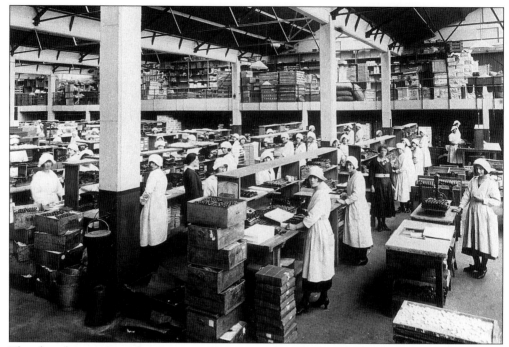

The chocolate-packing department at Paynes, in the 1920s, with trays of different chocolates being mixed and packaged by hand — the workforce was predominantly female.

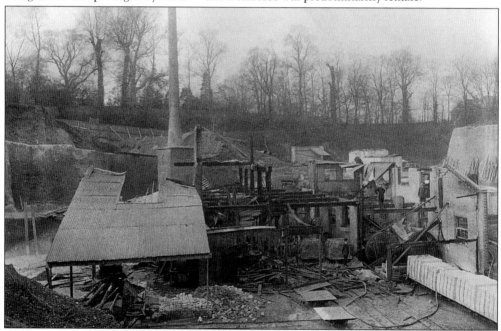

Messrs Jesse, Clack & Sons' Beddington Brickworks after a fire in April 1908. The brickworks were established around 1904 on part of a field known as 'Live and Repent' – now the site of Sherwood Park School. The distinctive white bricks were unusual because they were formed from a mixture of sand and lime rather than clay, and steam-heated rather than being fired in a kiln.

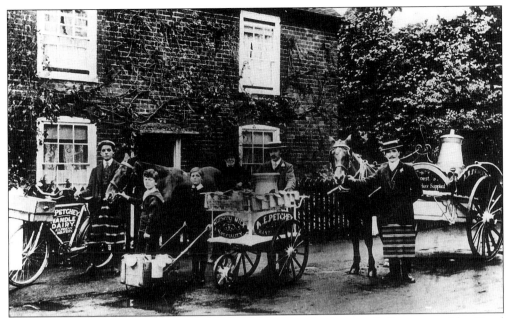

A. E. Petchey outside 'Hazel Cottage', with the Wandle dairy milk float ensemble. Hazel Cottage adjoined the Harvest Home public house in Beddington Lane. The dairy yard was located opposite in the outbuildings of 'The Willows'.

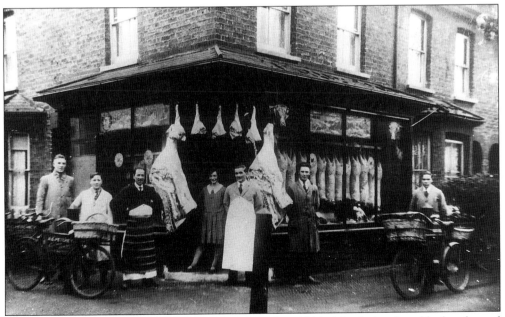

The staff of A.E. Petchey, butchers, Richmond Road, *c.* 1934. After being demobbed at the end of the First World War, Albert Petchey opened a butchers at what was formerly a greengrocers business on the corner of Wandle Road.

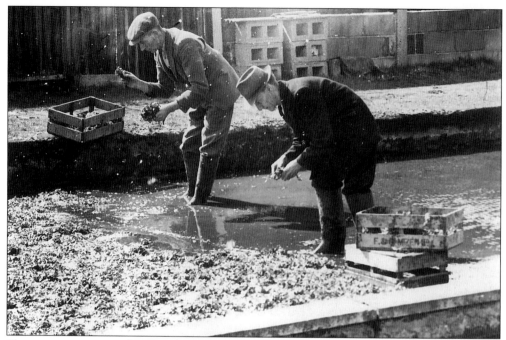

Planting watercress at Guy Road. Watercress growing was an important Wandle-side industry in the second half of the nineteenth and the first half of the twentieth century. These beds stood on the north side of the Wandle immediately upstream of Carew Manor. The box is marked with the name of F. & G. Mizen, market gardeners, who operated the beds between the wars. The beds were eventually filled in, in 1972.

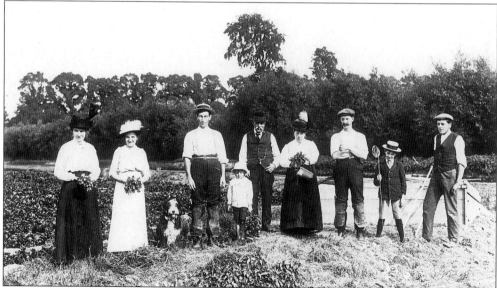

Picking cress at the Bridger watercress beds, c. 1917. The beds shown here lay along the north side of the Wandle at Richmond Green and were operated by Walter Bridger. The plants were grown in shallow running water and the harvester normally worked from a plank placed across the bed which protected the plants and prevented pollution. Here the cress is being made up into penny bunches rather than being boxed.

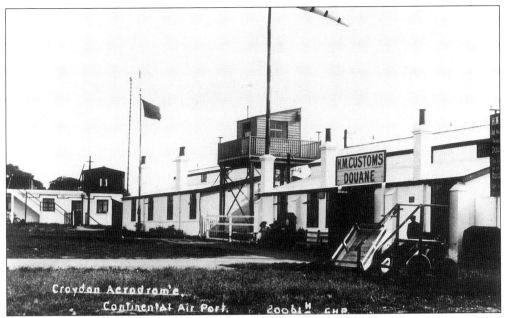

Croydon Aerodrome, London's first major international airport, *c.* 1922. The original wooden control tower with its balcony is in the centre, with the customs hall on the right. At this time the aerodrome was the customs' airport for London.

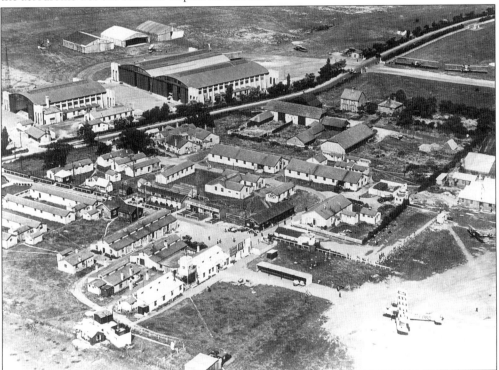

An aerial view of Croydon Aerodrome, *c.* 1924 with Instone Airlines and Air Union buildings in the centre. The second and enlarged control tower of the pre-1928 airport can be seen just below.

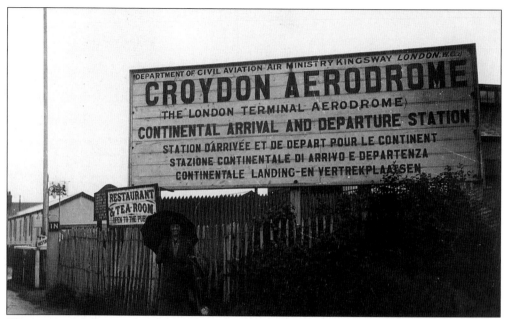

The main entrance to the aerodrome from Plough Lane, 1926. Immediately behind this sign stood the Trust House aerodrome hotel. It was replaced in 1928 by the Aerodrome Hotel, still standing today in Purley Way.

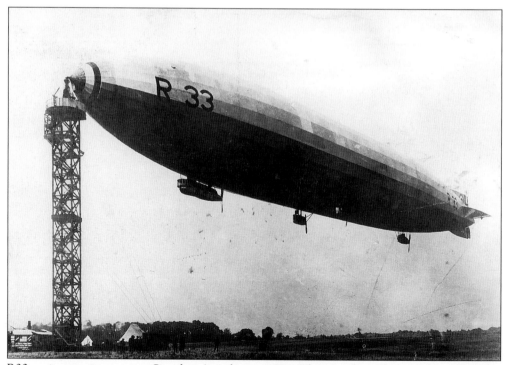

R33 on its mooring mast at Croydon Aerodrome, 1921. This was the only time the airship was moored at Croydon as it was discovered that the mast had been built on private land without permission and pilots considered it to be in too awkward a position.

Amy Johnson's arrival at Croydon after her record-breaking flight to and from the Cape, 18 December 1932. Her outward journey took 4 days, 6 hours and 54 minutes and the return, 7 days, 7 hours and 5 minutes.

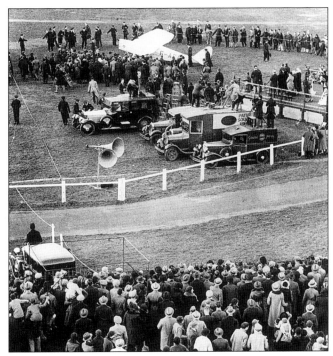

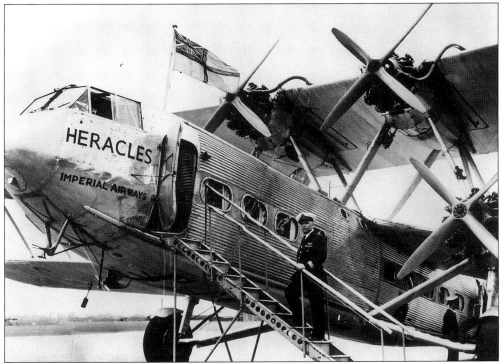

The Heracles, c. 1931. The first of Imperial Airways' four HP42s based at Croydon (in fact the world's first four-engined airliner), it was introduced on the London/Paris route in September 1931. Up to forty passengers could be carried in the relative luxury of wooden pannelling and plush upholstery.

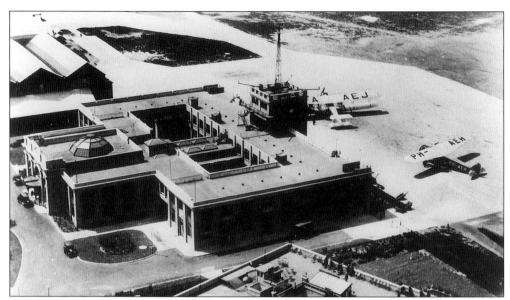

A view of the new aerodrome buildings and tower in the 1930s. The new and enlarged airport terminal, tower and hotel were opened along the newly created Purley Way in 1928. In the foreground is a Fokker F.VIII and in the background an A.W. Argosy.

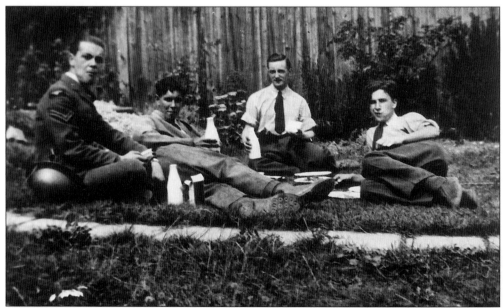

The crew of the 111th Squadron taking a tea break in the garden of the first house next to the aerodrome, in Foresters Drive, August 1940. Left to right: Jimmy Thrush, 'Lofty' Gardner, Charles A. Cooper and Tony Wilson.

Four

The Wandle

The Grotto Canal in Carshalton Park seen from the top of the Grotto, 1928. The canal was built at the beginning of the eigtheenth century as part of the grounds of Carshalton Park House. The canal was filled by a spring under the grotto which flowed more or less continiously until this century. It is now normally dry as large amounts of water are pumped out of the ground for domestic supply. The water empties into the Westcroft Canal.

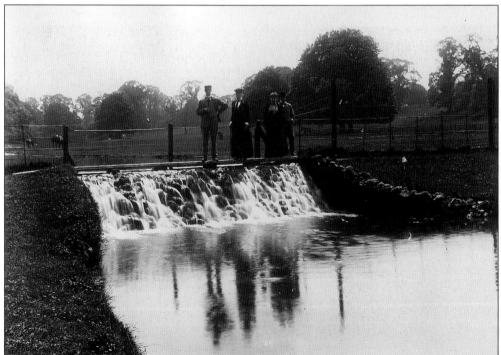

The waterfall in Carshalton Park around 1900. This still survives between Talbot Road and the High Street, although it is now generally dry.

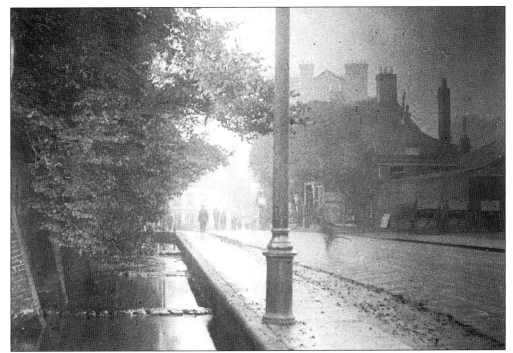

Until the 1930s a stream ran along the south side of Carshalton High Street between the road and the boundry wall of Carshalton Park House. The water came down a culvert from the Hog Pit in Carshalton Park. It reached the High Street at the highest point, hence the water flowed both west towards Carshalton Ponds and east towards the Westcroft Canal.

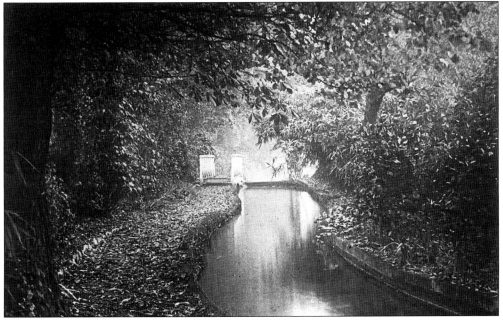

The water from the Grotto Canal passed under the High Street and through the grounds of a house called Bramblehaw which stood in the triangle of land between Acre Lane and Westcroft Road.

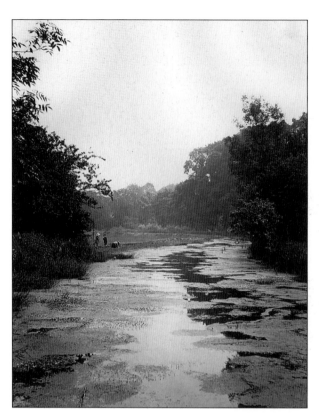

From Bramblehaw, the Wandle ran under Westcroft Road into the Westcroft Canal which still survives on the east edge of Grove Park next to the Sports Centre. The canal supplied water to the Grove ironworks mill shown below.

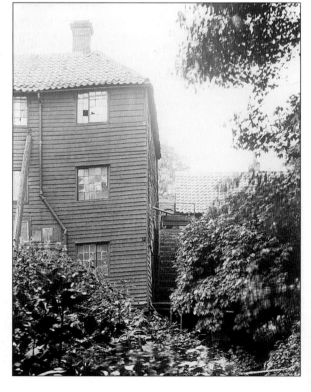

The Grove ironworks mill was a large weather-boarded mill standing near the river just above Butterhill Bridge. In 1805 the upper part of the mill was used for grinding tobacco into snuff and the lower half held boring machines for making cannons. It later became an iron works and was destroyed by fire in 1944.

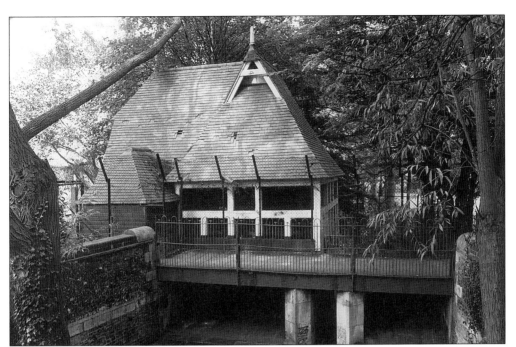

The upstream side of the Grove mill in July 1987. This may well be the site of the mill which existed in Carshalton when the Domesday Book was compiled in 1086. The existing structure dates back to the 1780s when the Portland stone wheel pits were made to power a corn mill. They were designed by John Smeaton who is best known for constructing the third Eddystone lighthouse. The corn mill was demolished around 1887 and the alpine style wooded building was erected to house a dynamo which supplied electricity to the Grove and Stone Court.

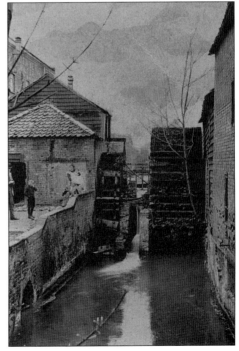

The mills at Butter Hill, Carshalton, c. 1910. At the beginning of this century there were three mills on the Wandle immediately above Butter Hill Bridge. One of them, on the right of this photo, was a snuff mill which had been operated by the Ansell family since the late eighteenth century. The second, to the left, was also used by Ansells although it appears to have once been a small corn mill. The third, which can be seen in the background on the far left was at the end of its life, a large brick-built flour mill operated by Denyers.

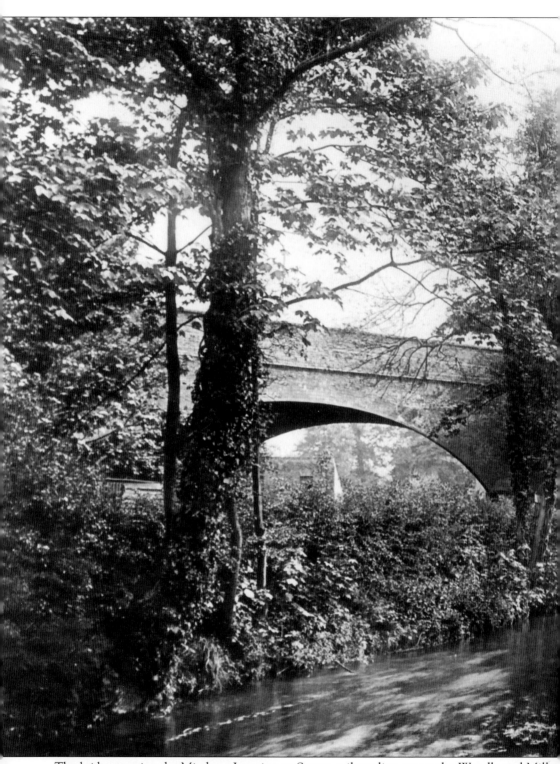

The bridge carrying the Mitcham Junction to Sutton railway line across the Wandle and Mill Lane, *c.* 1900. Butter Hill Bridge and Ansell's snuff mill can be seen in the background. The

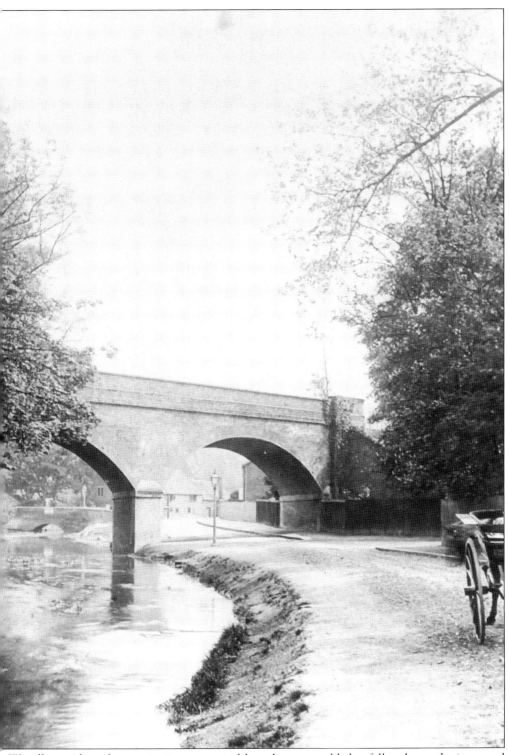

Wandle was then about twice its present width as the water table has fallen due to the increased demand from the mains supply.

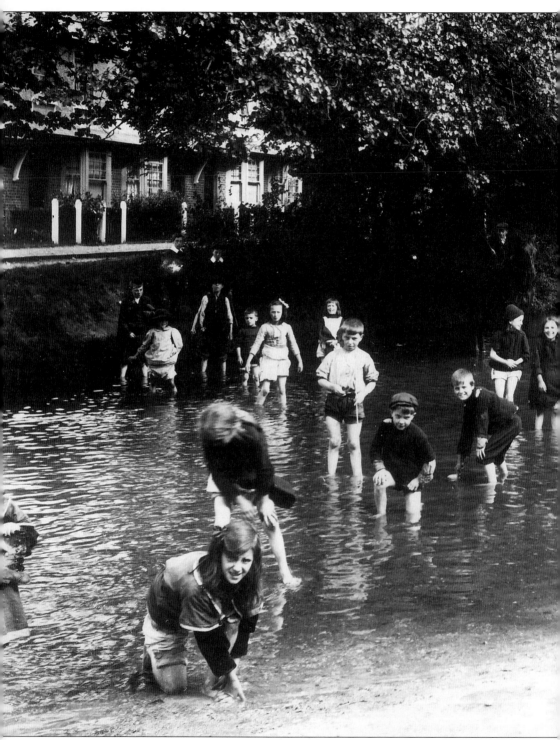

Children playing in the fords, Beddington, *c.* 1915. The view looks up the Wandle from the bridge at the north end of Hilliers Lane. The river here is quite shallow. Before the bridge was built carts had to ford the river between Hilliers Lane and Beddington Lane.

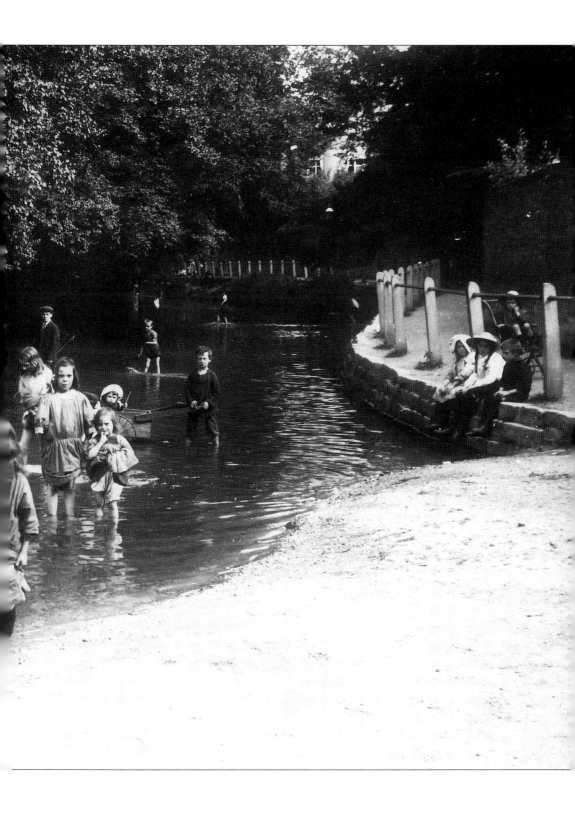

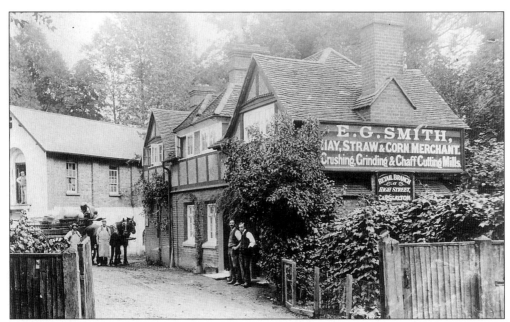

Wallington Bridge Mill, early this century. When this photo was taken it was grinding animal food and cutting chaff but it had formerly been used for paper making and flour milling. The site was later used by the Helm Royal Chocolate Factory and is now a car park.

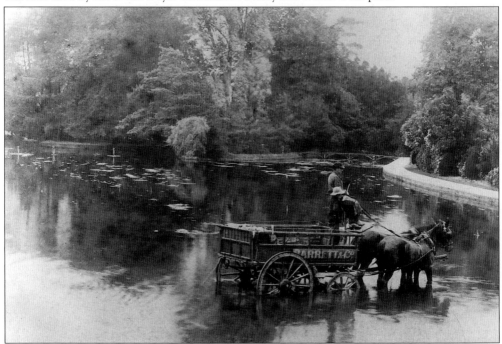

Looking downstream from Hackbridge in 1885. The river could be forded at this point but the cart has probably been posed for effect as the Hackbridge has existed since the middle ages. The southern tip of Culvers Island, which was laid out as part of the gardens of the Culvers, can be seen in the background. The path and shrubs on the right are part of the garden of Hackbridge House.

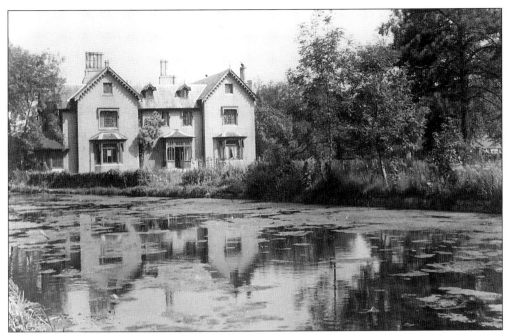

Culvers House stood on an island in the Wandle just north of the modern Culvers Avenue. It was built in the late 1830s by Samuel Gurney who was a partner in the Overend and Gurney Bank. When this went bankrupt, in 1866, the house was sold to John Peter Gassiot, who added various features to the gardens and grounds. On his death, in 1902, the estate was again sold but the property was allowed to fall into decay. The house was finally demolished in 1958.

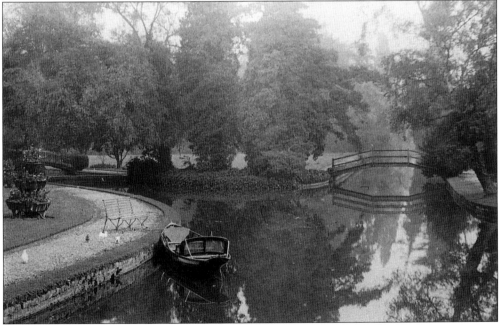

The garden of The Culvers, looking south-east from the house, c. 1900. Culvers had an elaborate garden through which the Wandle passed by a series of ornamental canals. The boat shown was presumably used around the garden as the river was not navigable for any distance.

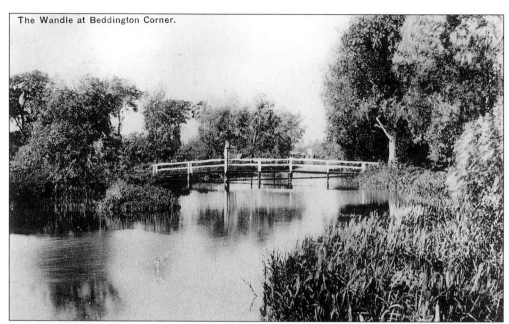

The Wandle at Beddington Corner, downstream from Goat Bridge, around the turn of the century.

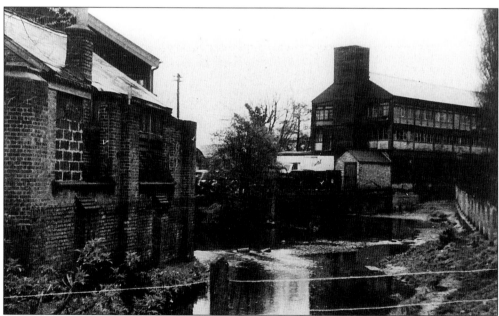

There were three mills on the Wandle immediately above Goat Bridge, two on an island in the river and one on the east bank. This photo shows the skinning mill which stood on the island from at least 1744. The building on the right was a drying shed.

126

This shows the upstream side of the other two mills above Goat Bridge. The building on the left was part of the leather works shown in the previous photo. The mill on right was used for grinding drugs and dyestuffs.

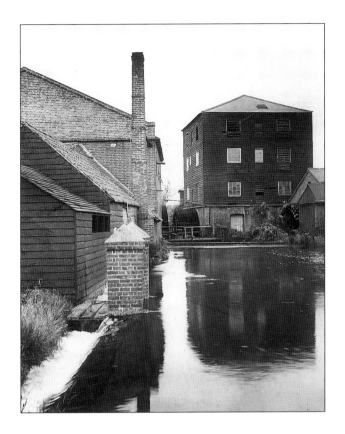

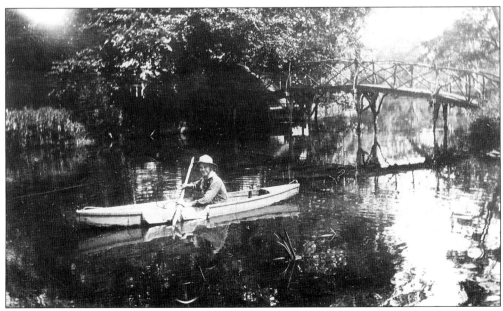

Mr A. Howard on the Wandle below Goat Bridge, *c.* 1923.

Acknowledgement

We would like to thank Barrie King, Mr G.F. Crabb, the *Sutton Herald*, and all those individuals who, over the years, have so kindly donated their photographs to the Local Studies Collection. A special thanks also to Bev Shew for her assistance with the Beddington section, and to the other staff of the Heritage Service.